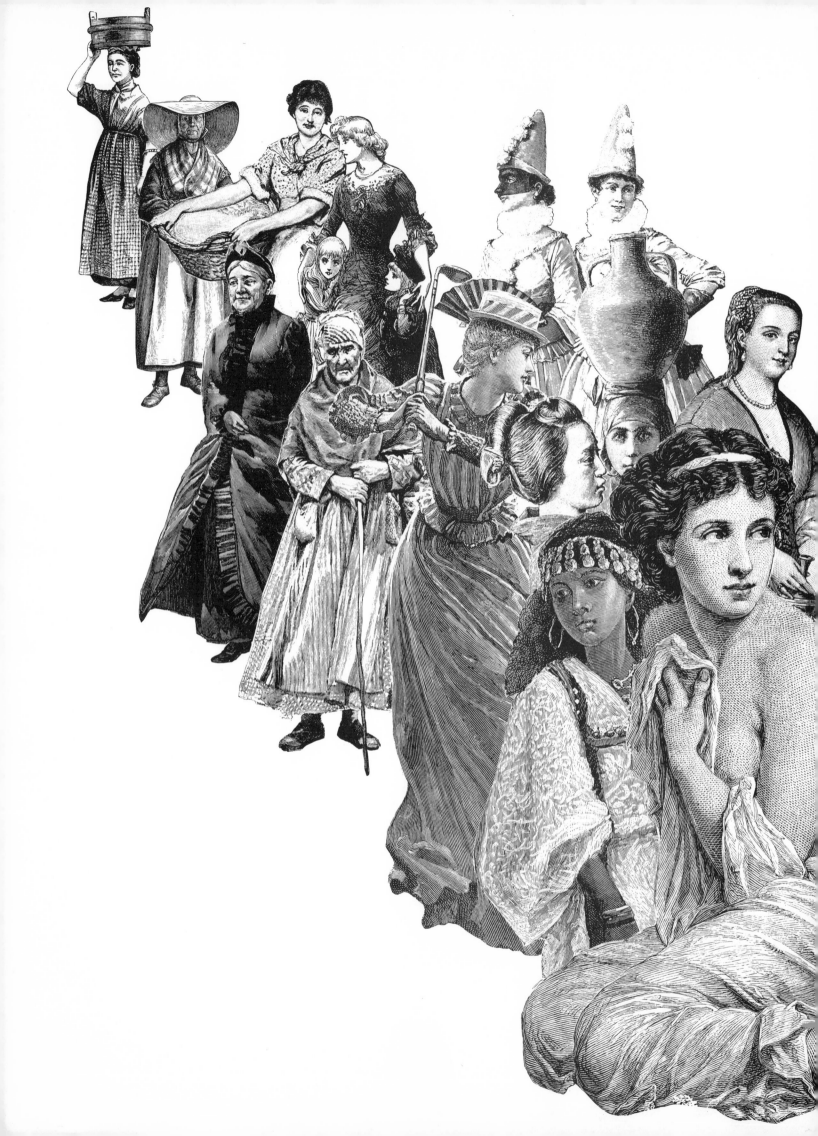

WOMEN

A PICTORIAL ARCHIVE FROM NINETEENTH-CENTURY SOURCES

488 Copyright-free Illustrations for
Artists and Designers

Selected by
JIM HARTER

Second, Revised Edition

Dover Publications, Inc.
New York

Published in Canada by General Publishing Company, Ltd., 30 Lesmill Road, Don Mills, Toronto, Ontario.
Published in the United Kingdom by Constable and Company, Ltd., 10 Orange Street, London WC2H 7EG.

Women: A Pictorial Archive from Nineteenth-Century Sources is a new work, first published by Dover Publications, Inc., in 1978. Second, revised edition published in 1982.

DOVER *Pictorial Archive* SERIES

International Standard Book Number: 0-486-23703-6
Library of Congress Catalog Card Number: 78-59233

Manufactured in the United States of America
Dover Publications, Inc.
31 East 2nd Street
Mineola, N.Y. 11501

PUBLISHER'S NOTE

Wood engravings, with their crisp black-and-white lines, were popularized by Thomas Bewick at the end of the eighteenth century and quickly became the favored medium of mass reproduction of artwork in the nineteenth. While there were only about 20 wood engravers in the United States in 1838, by 1870 their number had swelled to about 400. Most of them earned their living by engraving illustrations for the great periodicals of the era, *Harper's Weekly* and *Leslie's Illustrated* foremost among them. With great skill the artists rendered sketches and photographs into precise illustrations. The medium admitted a wide variety of styles from simple, bold line drawings to those so carefully worked that the effect of gradation of tone was achieved, sometimes with an impressionistic feeling.

By the mid-1880s the means had become available for reproducing photographs as halftone illustrations, but they were both crude and expensive. It was not until the 1890s that the art of wood engraving began to be superseded by the new process. Ironically, now that the technique of the wood engraving has been largely lost, the popularity of these illustrations is reviving. Artists find the material widely adaptable to projects such as collage. Graphic designers are rediscovering how well the engravings complement typography.

Using his keen eye, artist Jim Harter has culled this selection from issues of *Harper's*, *Leslie's*, *The* [London] *Graphic* and *The London Illustrated News*. He has chosen the material to reflect both the diversity of the subject and the variety of styles of wood engraving. It has also been selected to be of maximum use to artists and designers.

While the purpose of this volume is not intended to be sociological, it is impossible to look at the illustrations on these pages without noticing how the Victorians preferred to view women in their conventional roles of mother and housewife, to which was added an aura of sentimentality. Nevertheless, there is diversity. Allegorical ladies swirl across the heavens; women tend factory machines. A blacksmith stands at her forge on one page; on another, an odalisque reclines sensually on her divan.

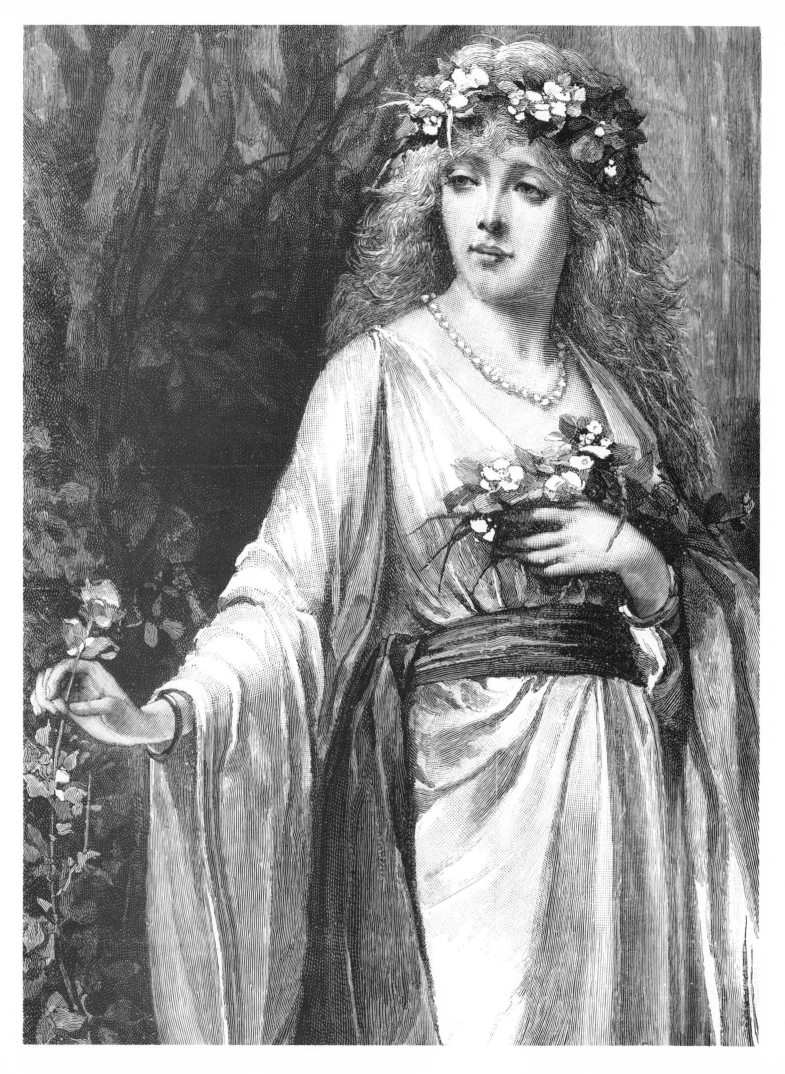

1

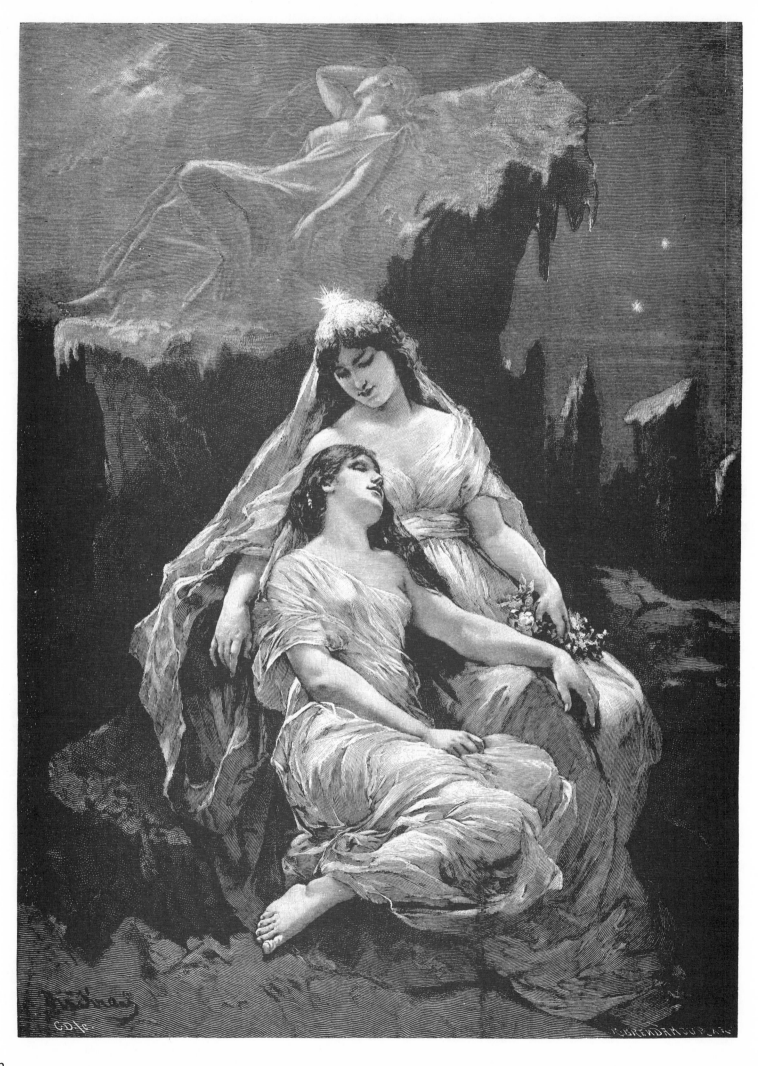

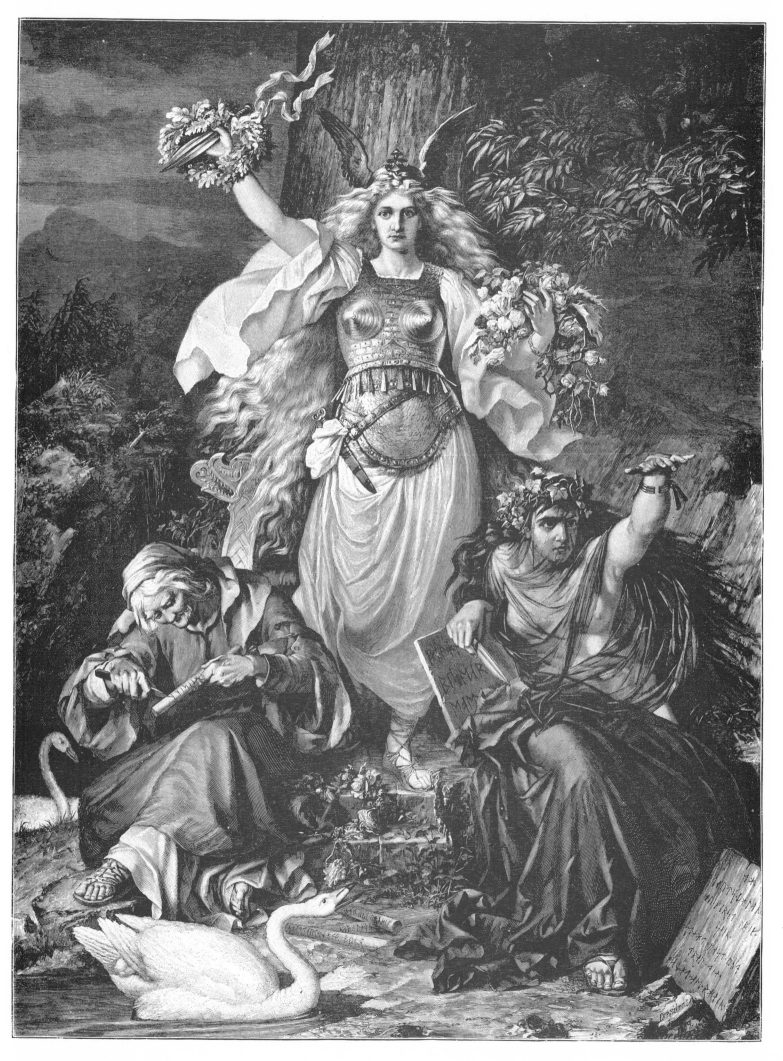

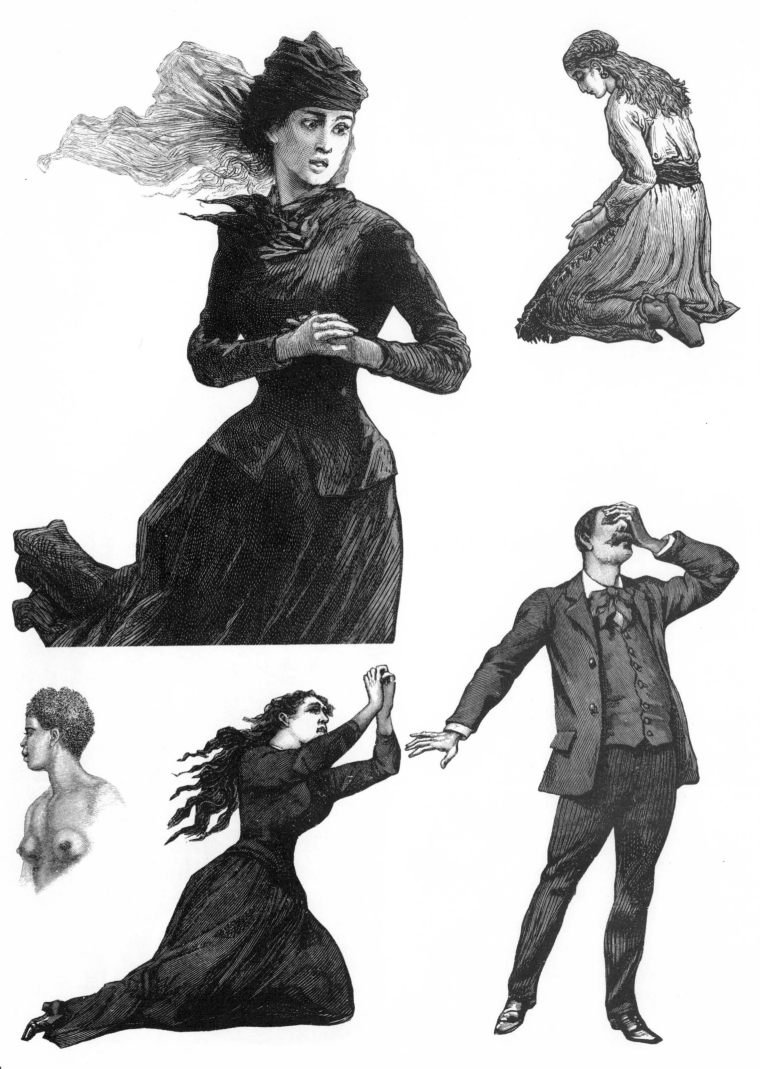

4

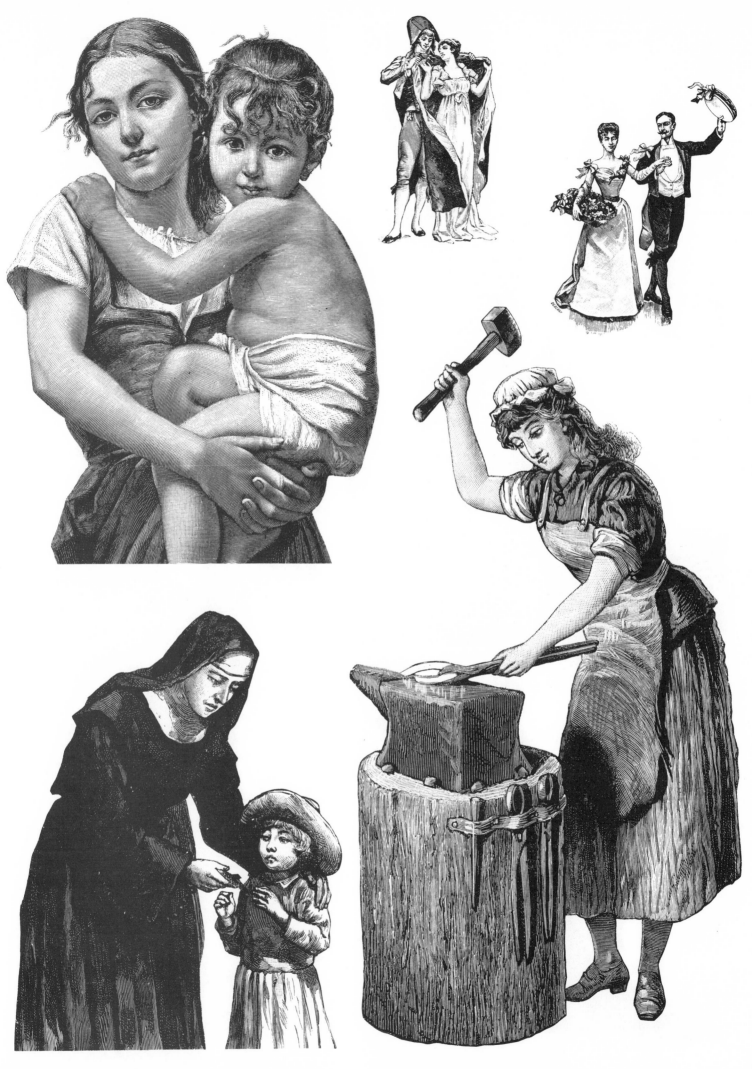

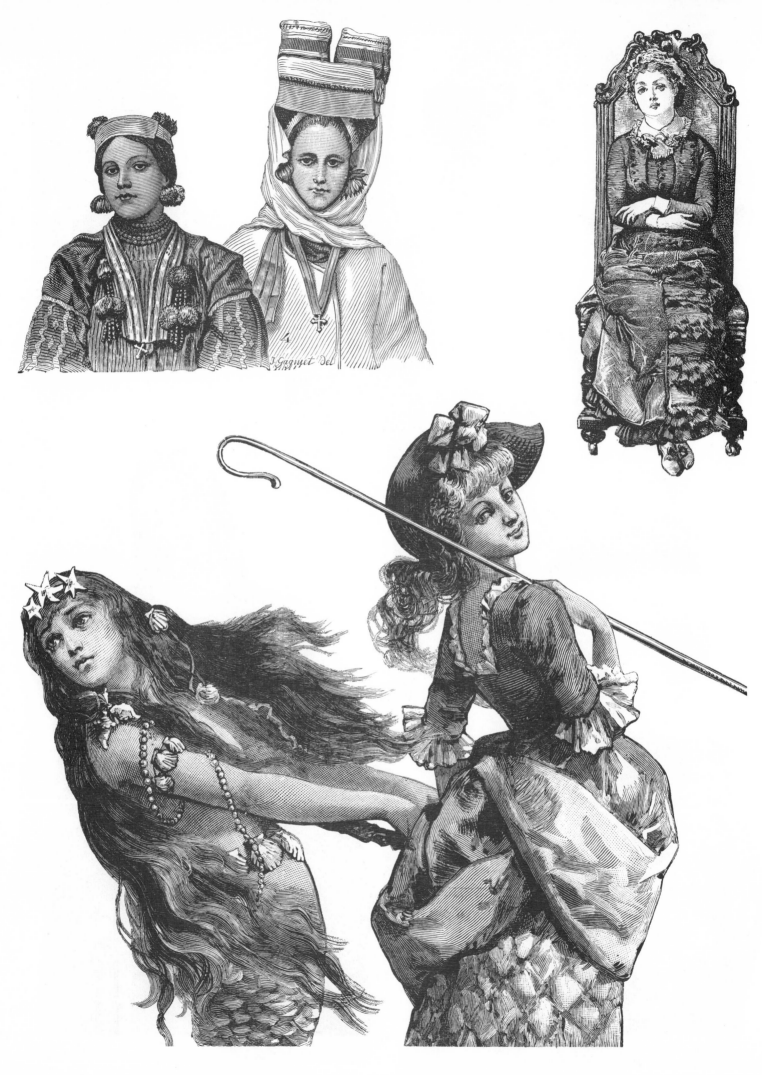

4

J. Gaguet. Del

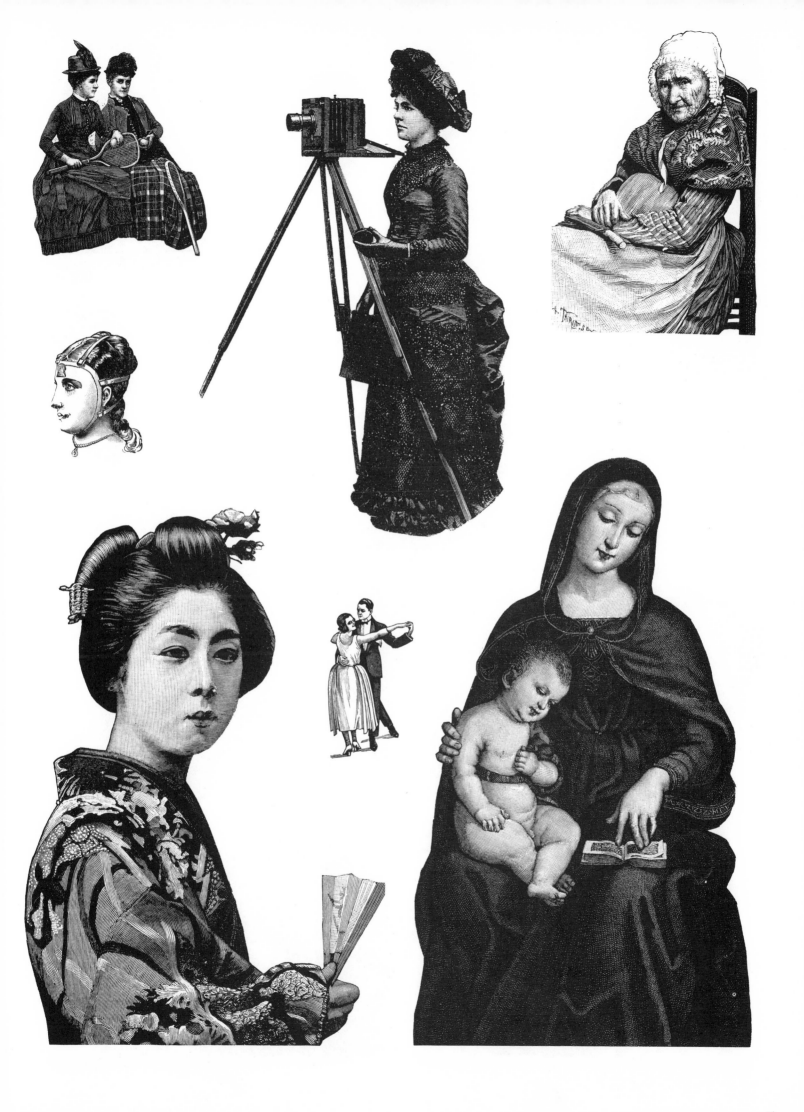

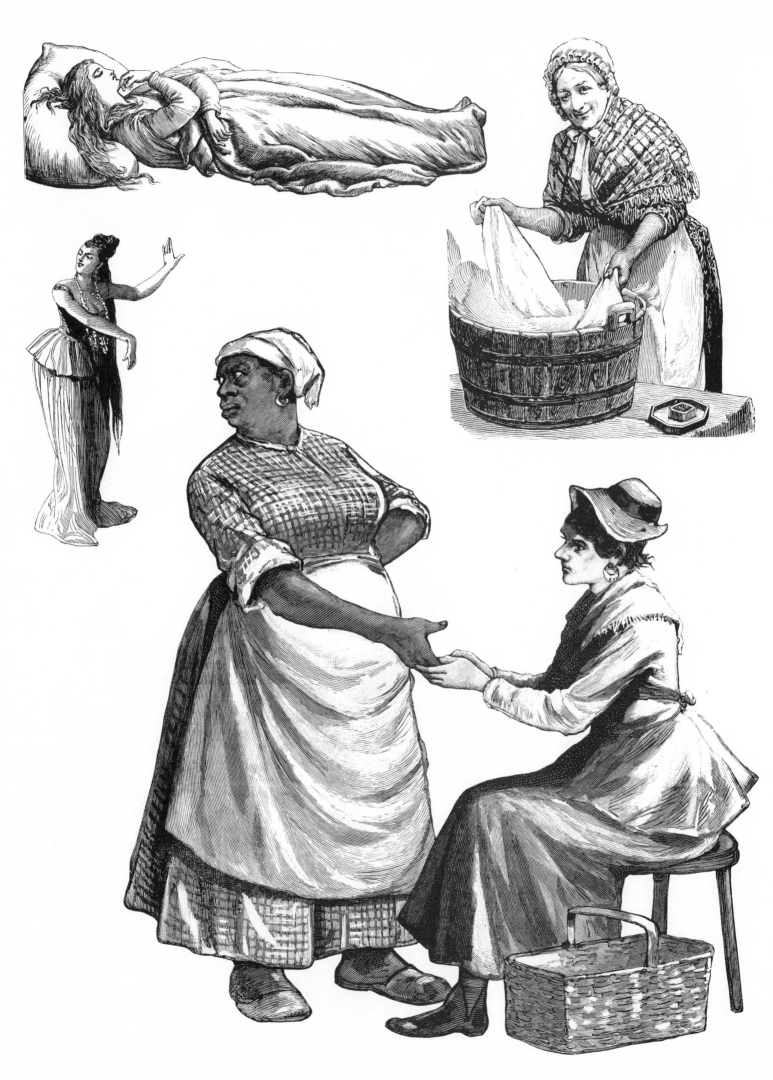

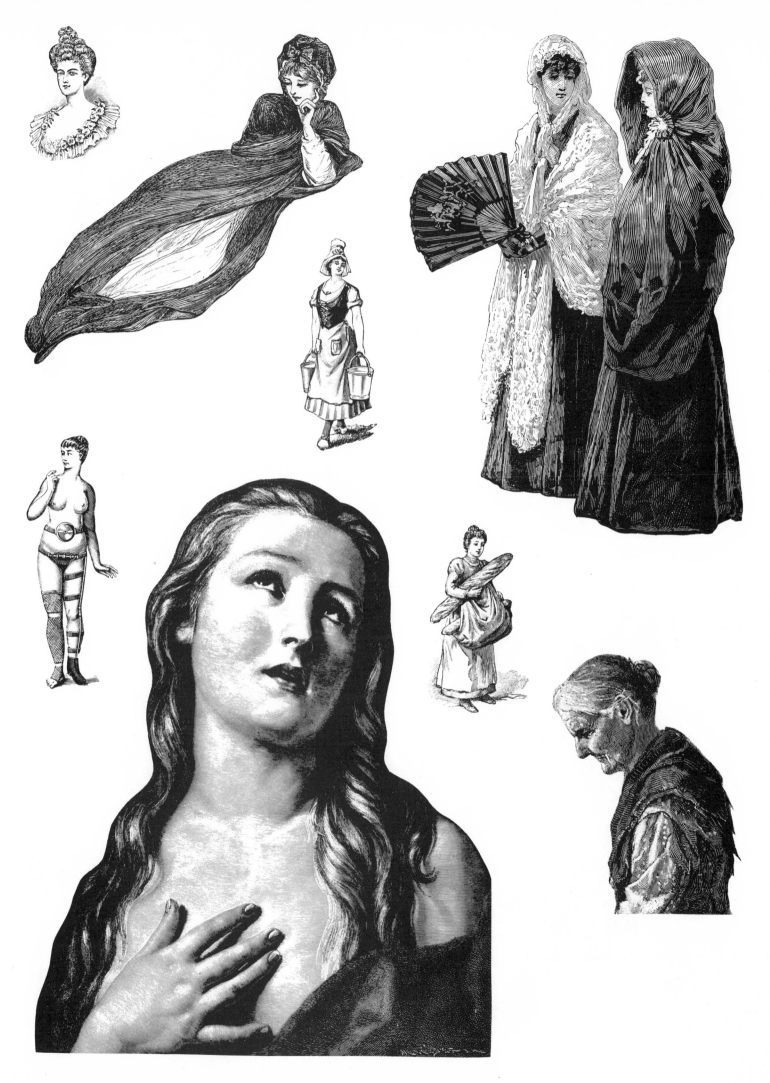

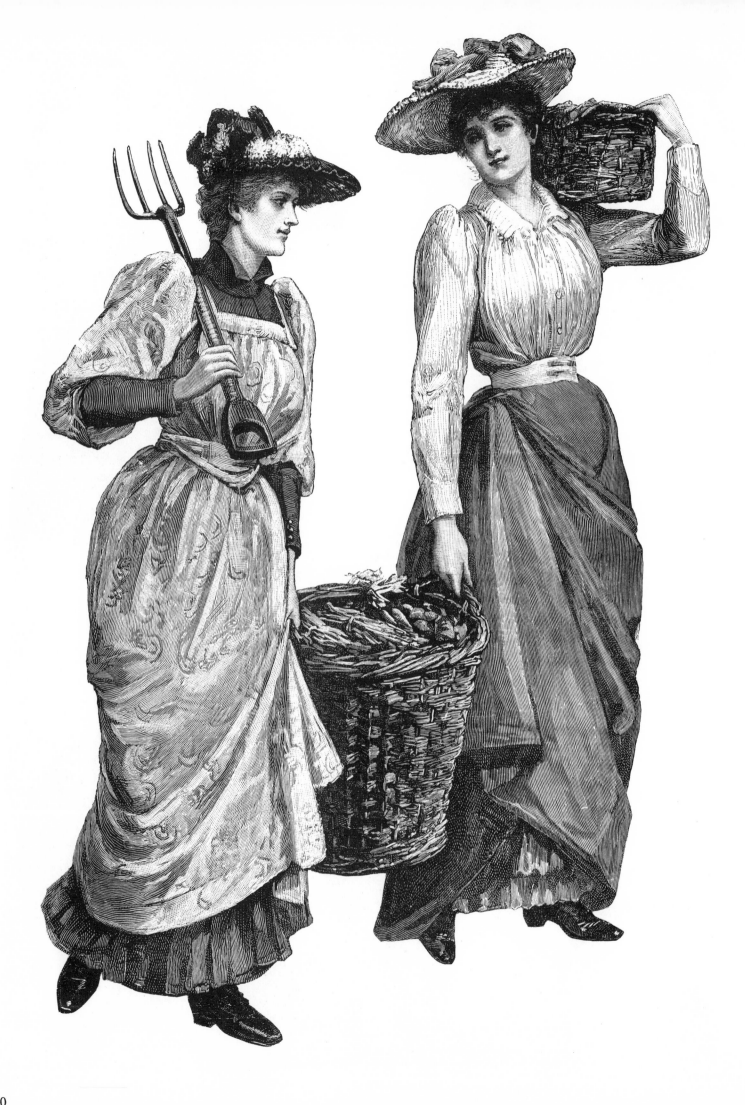

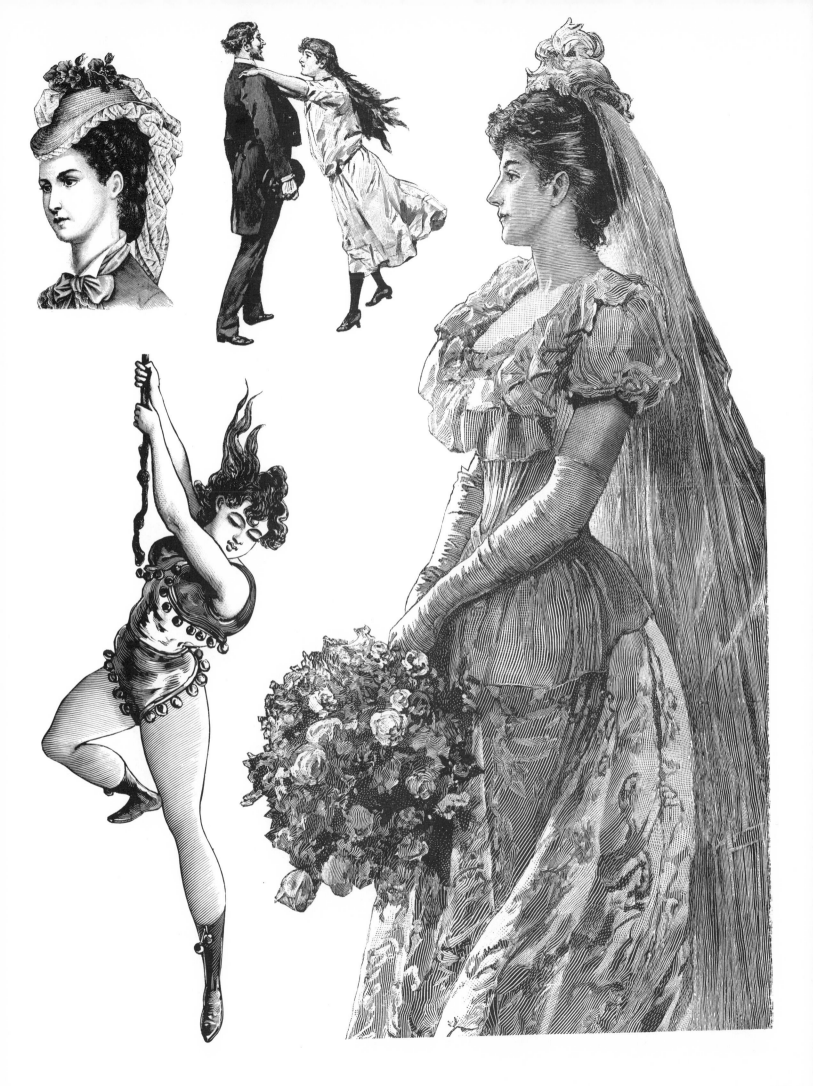

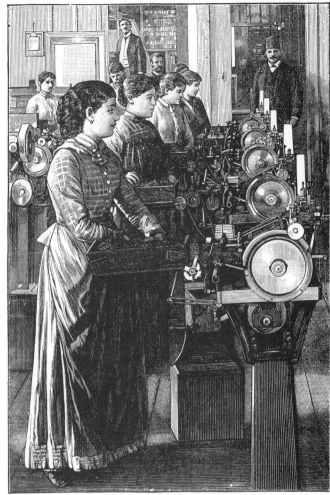

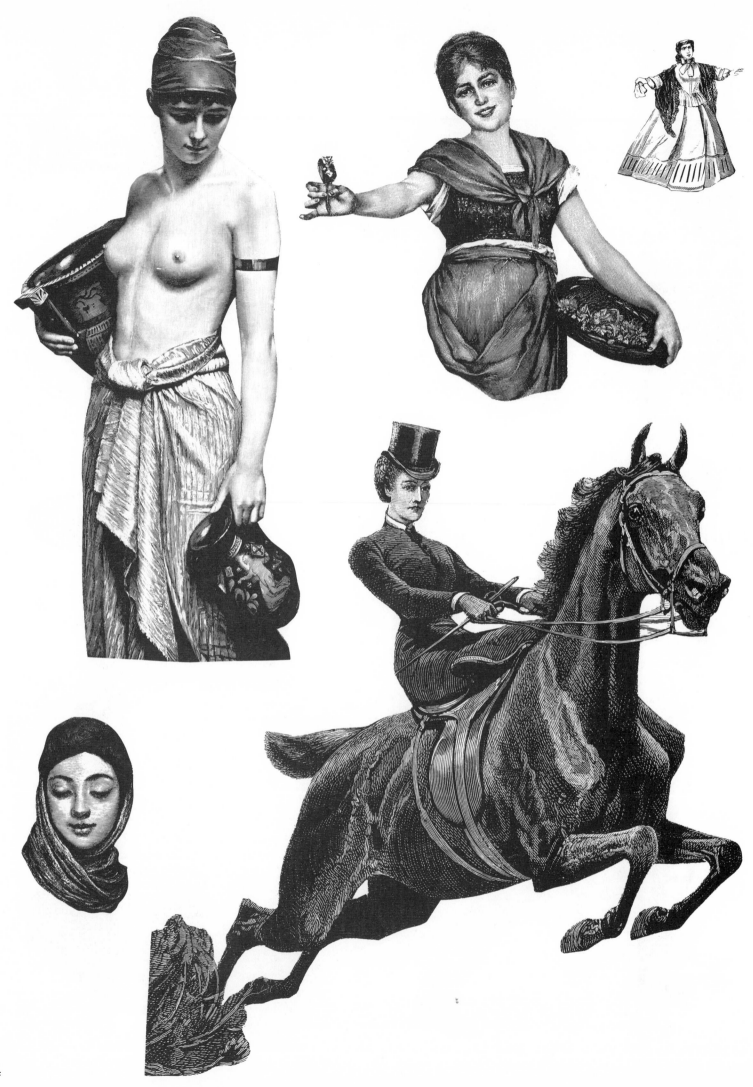

14

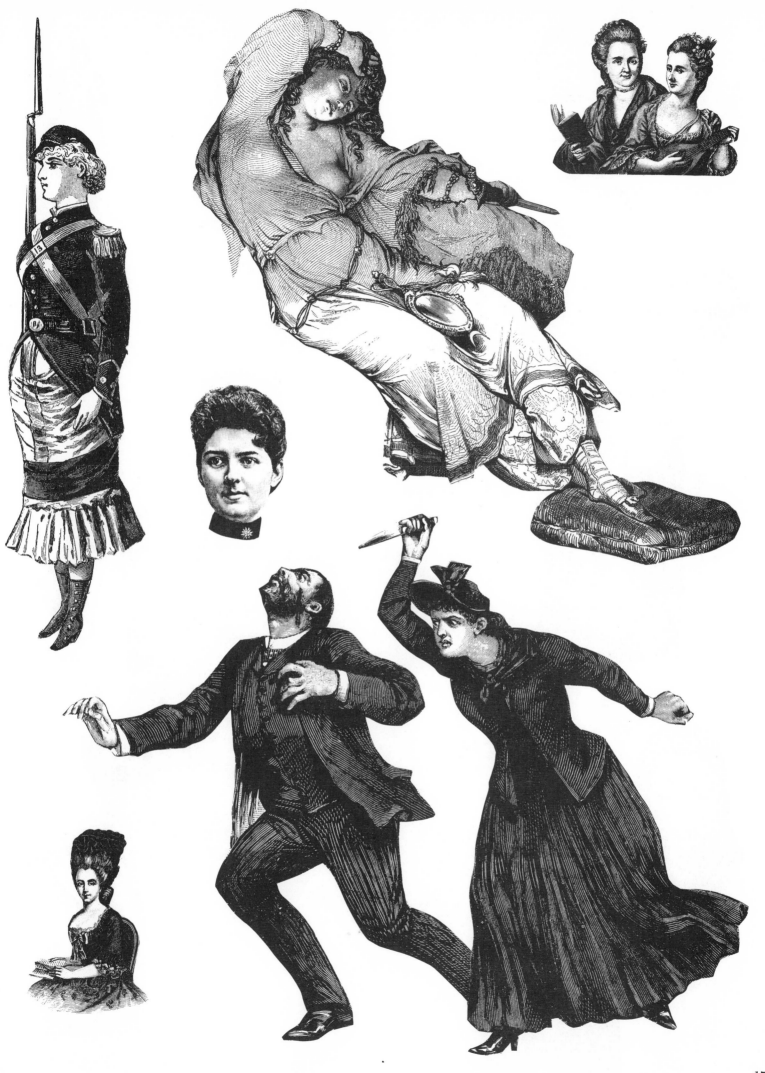

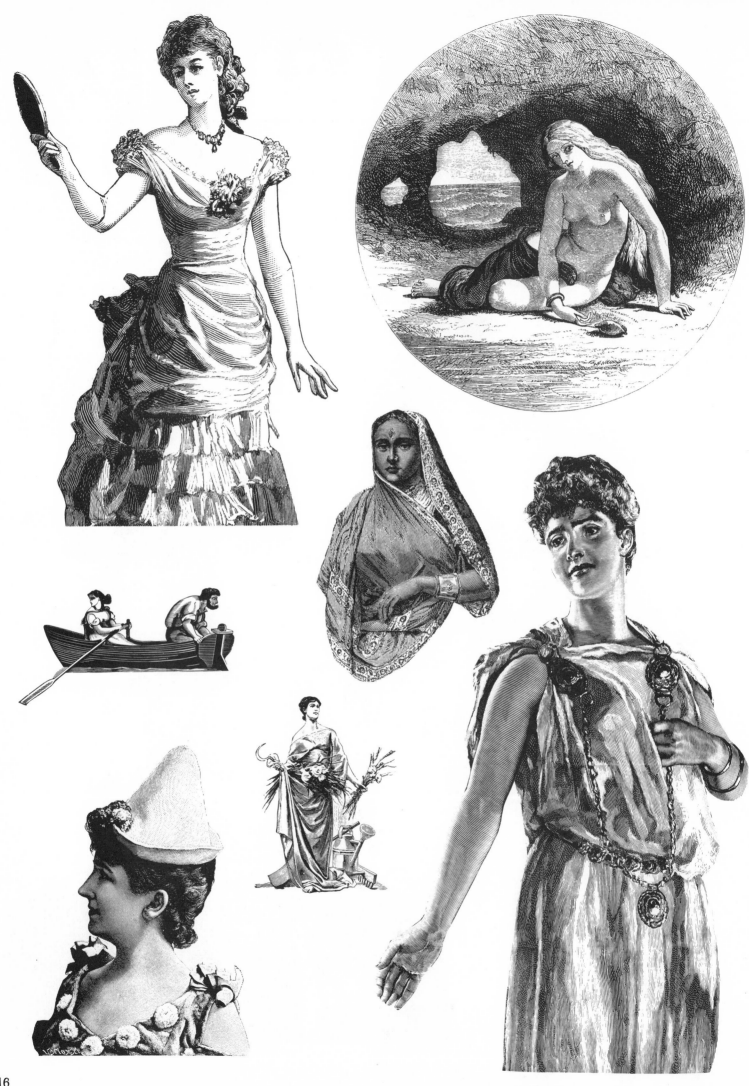

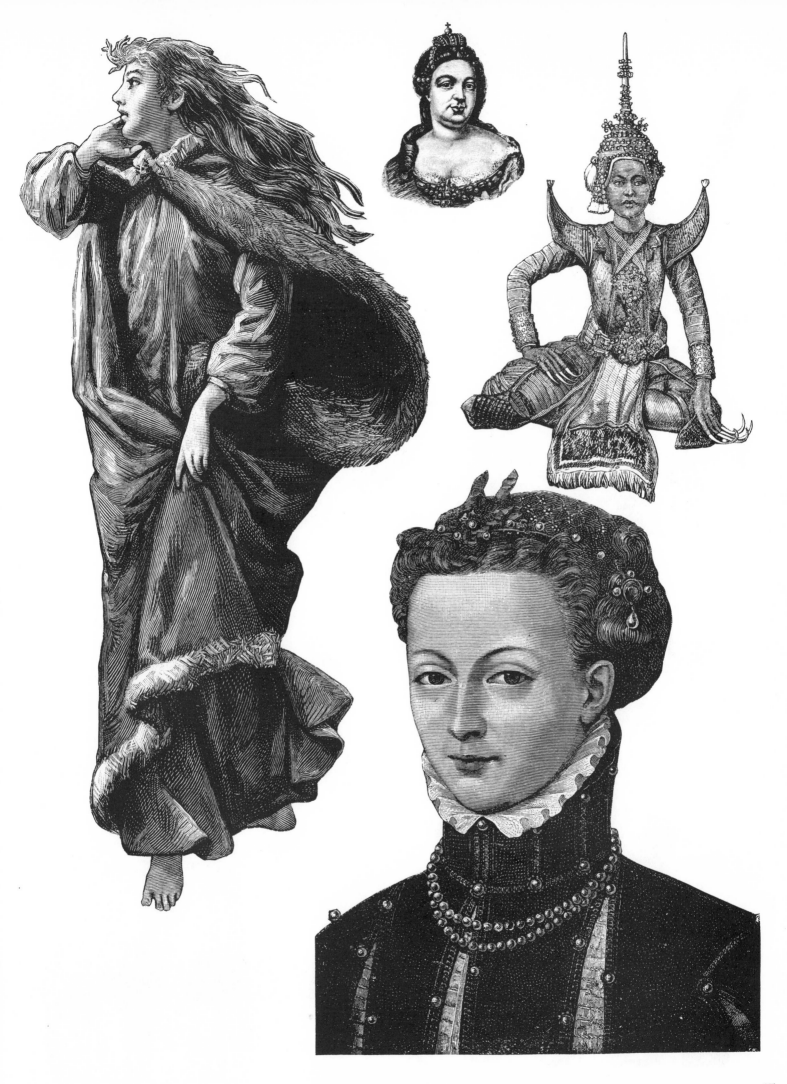

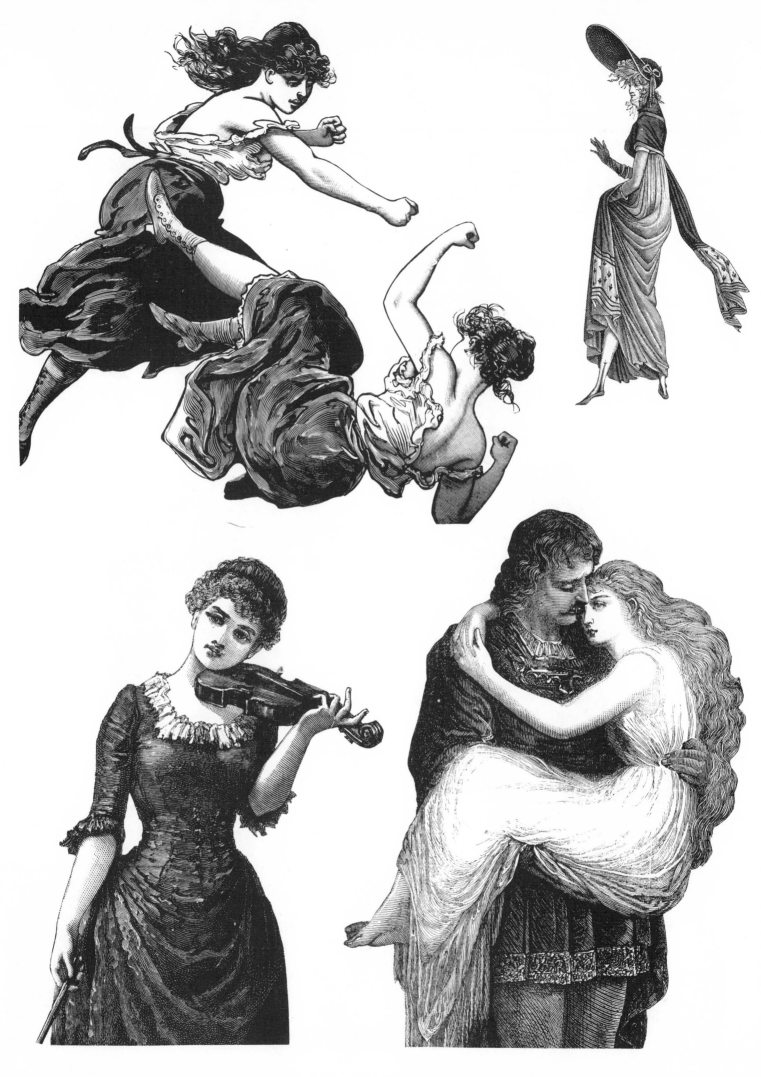

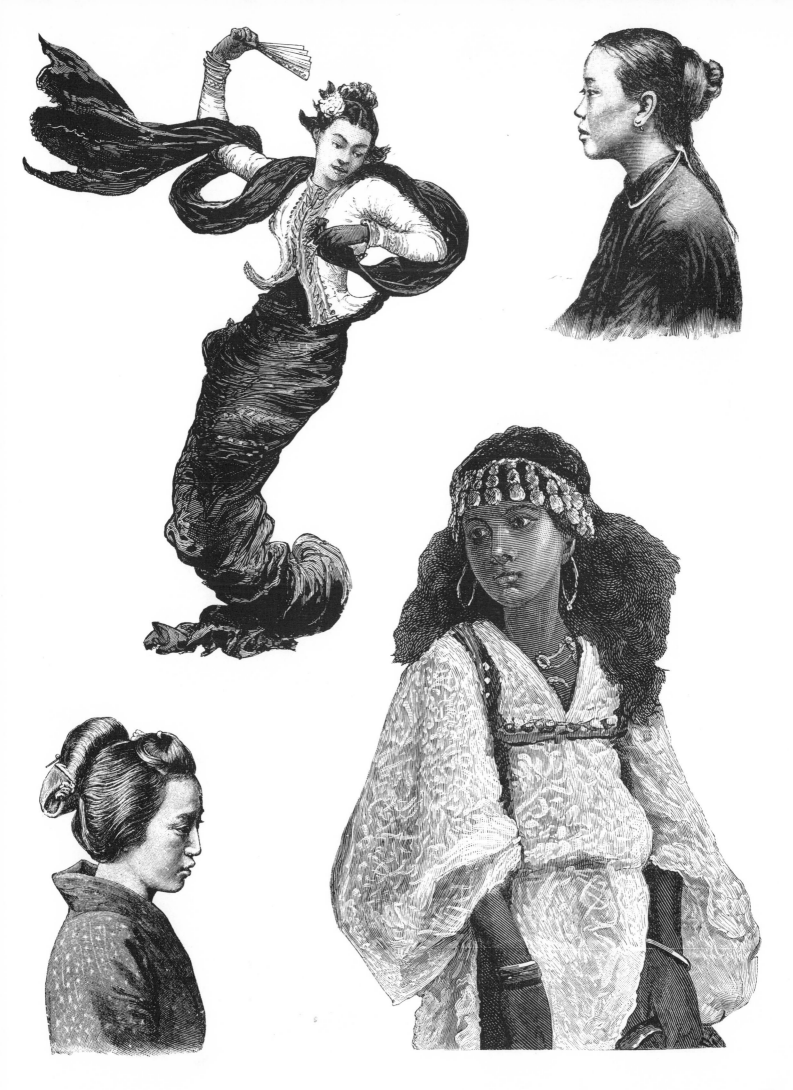

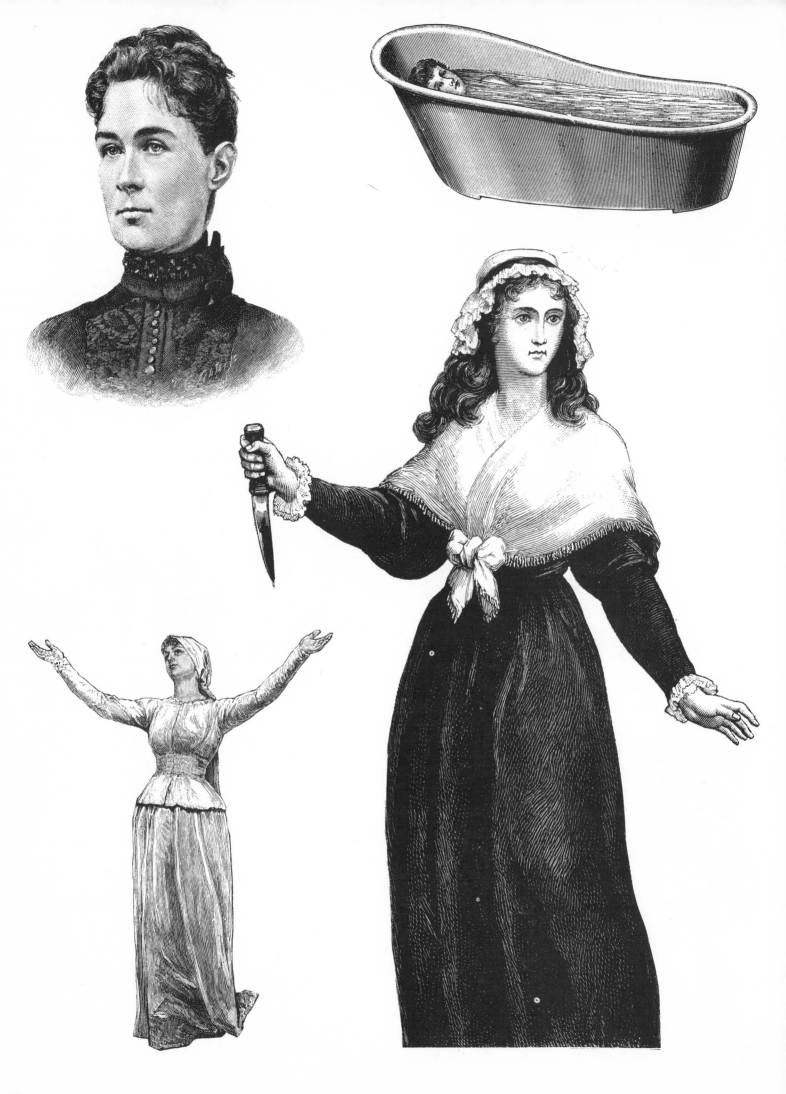

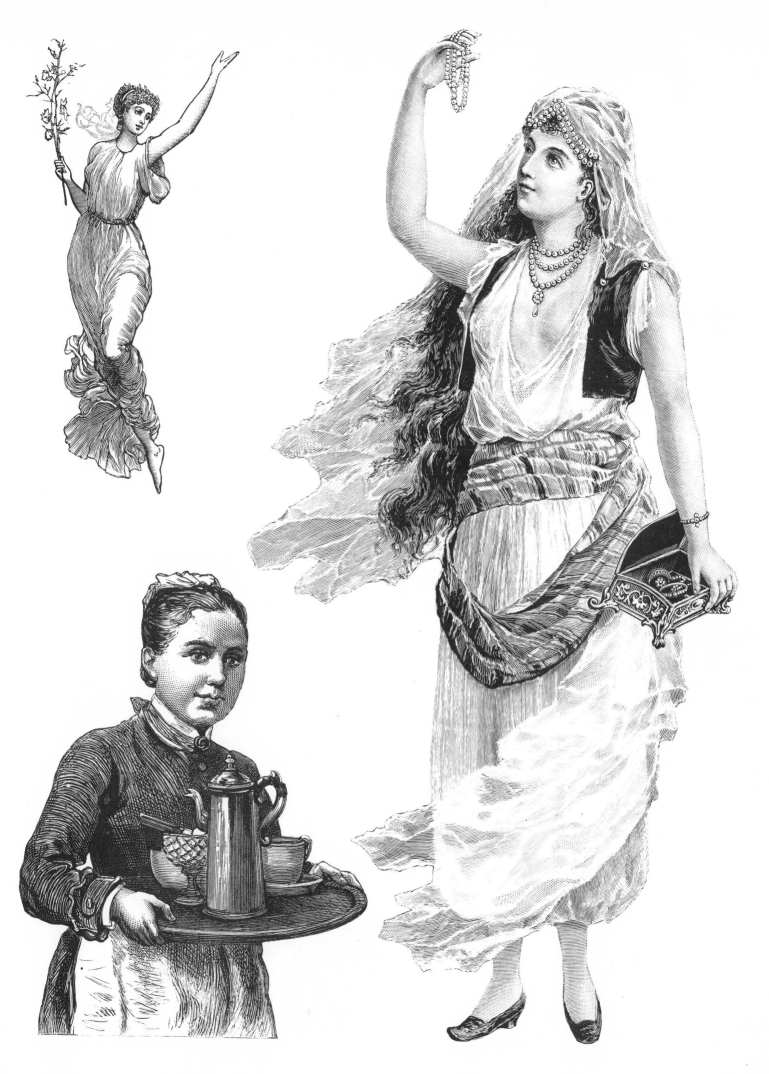

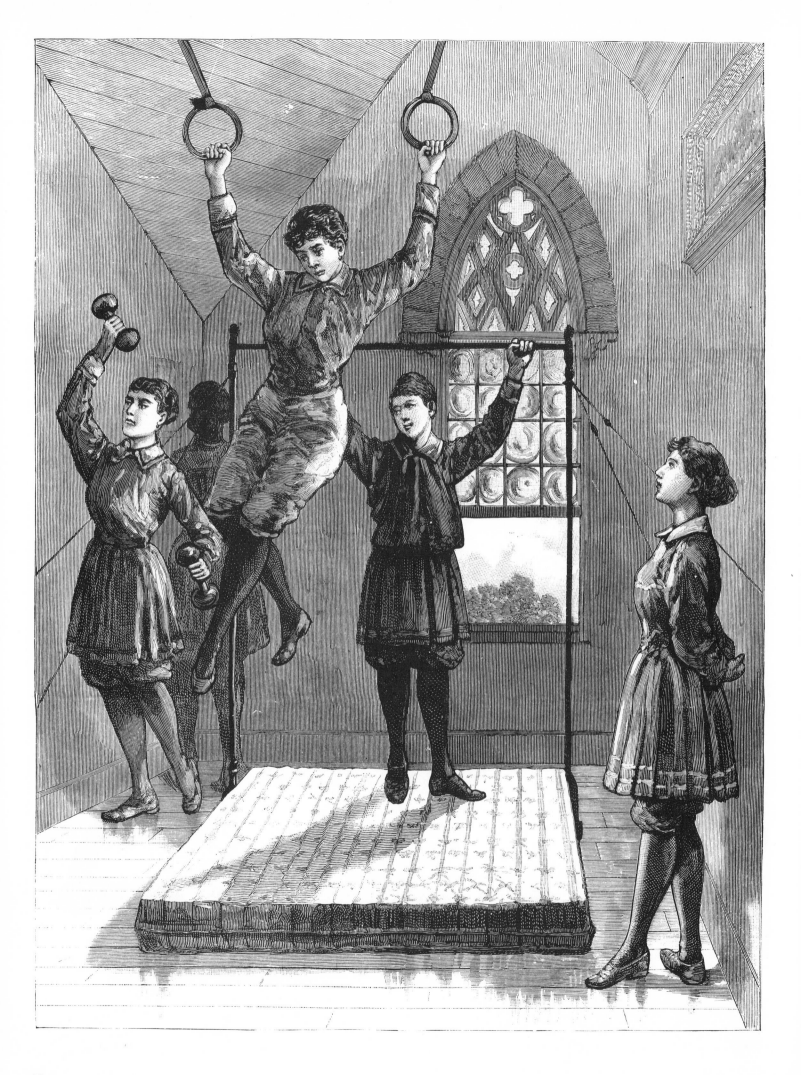

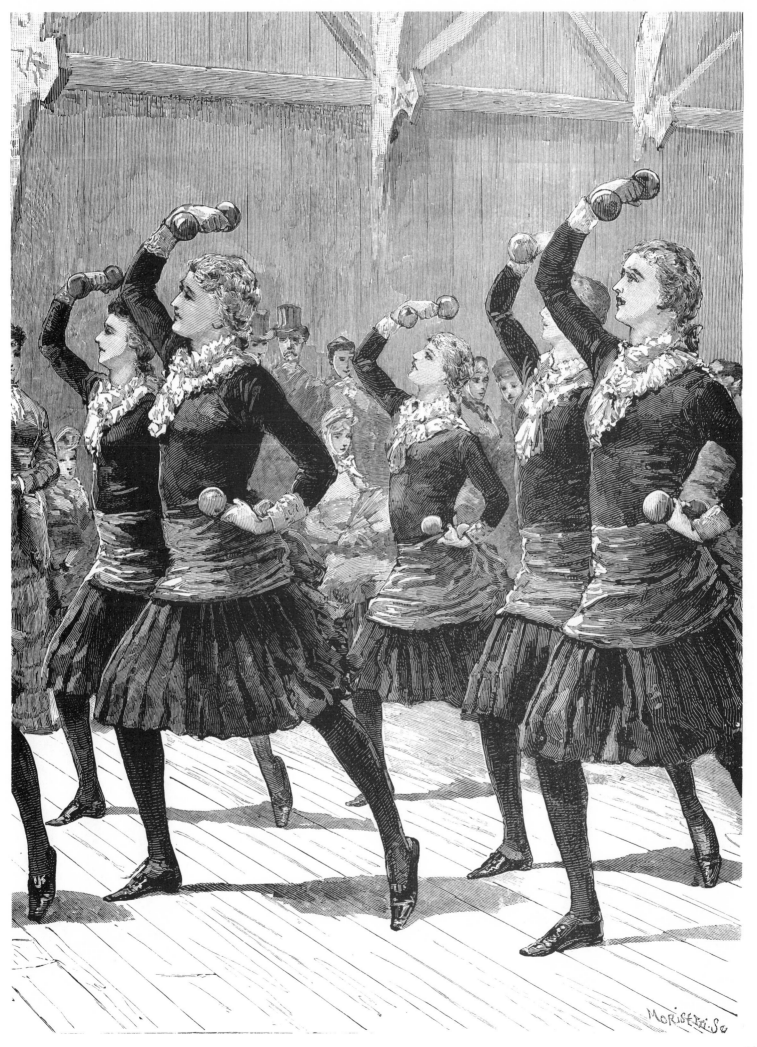

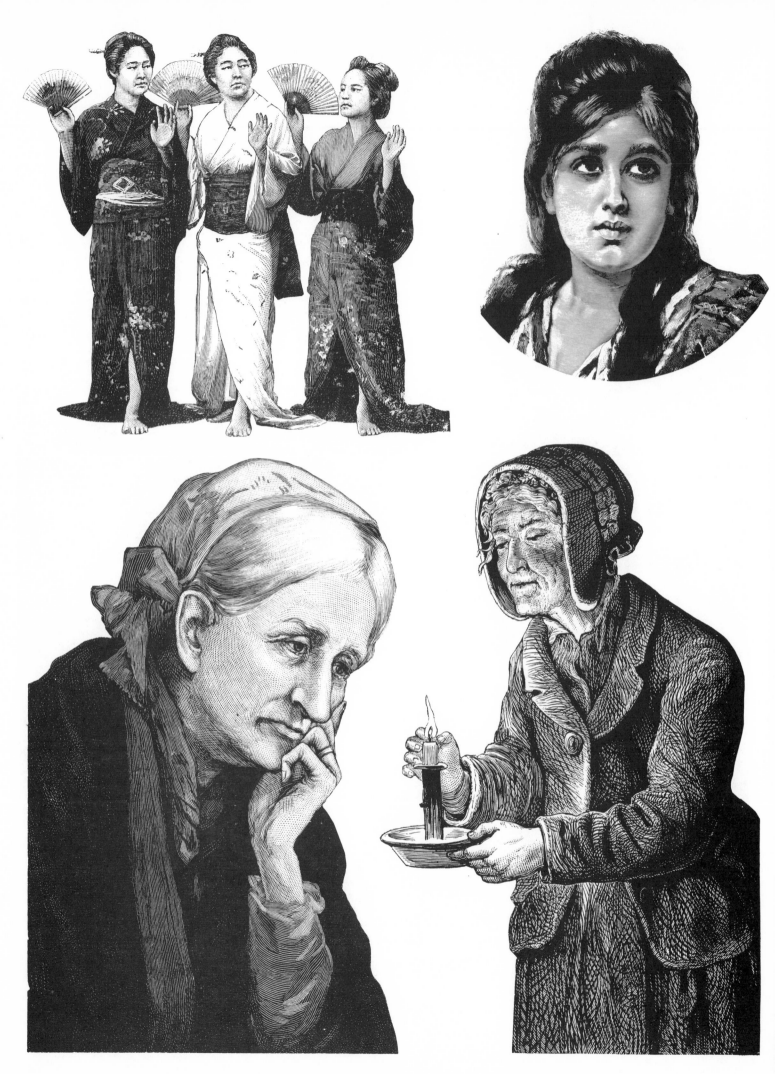

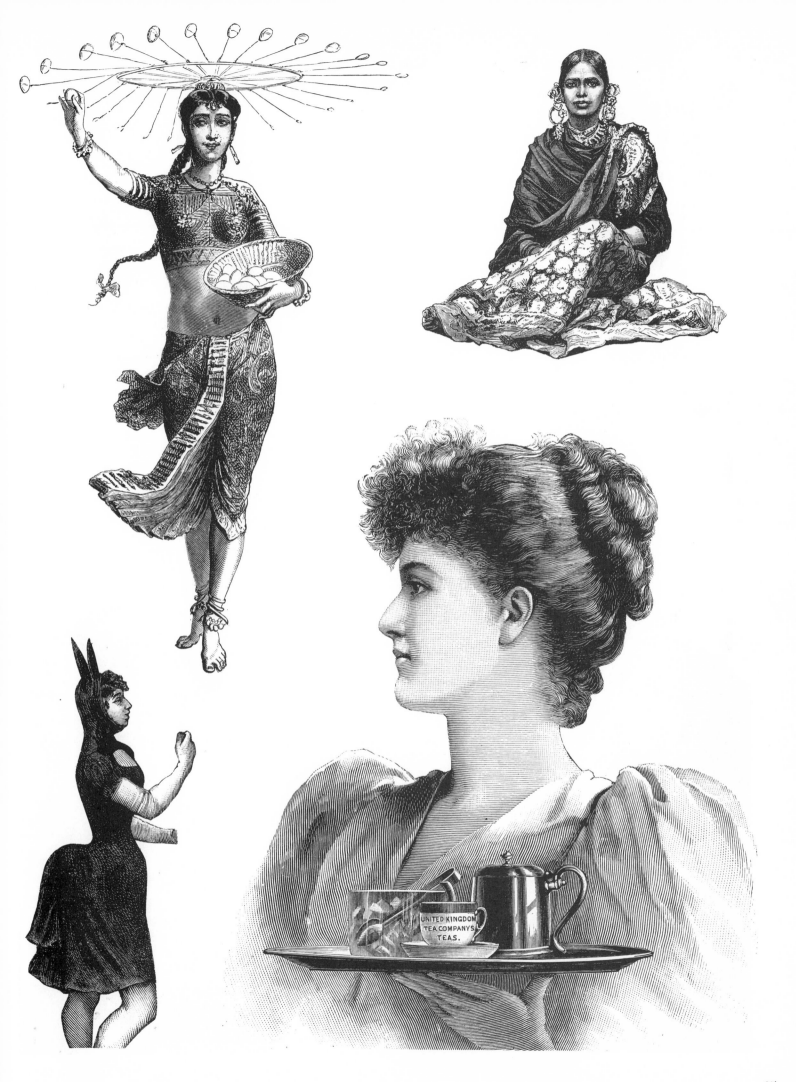

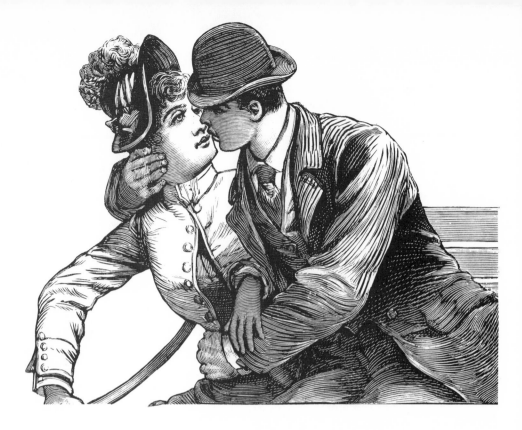

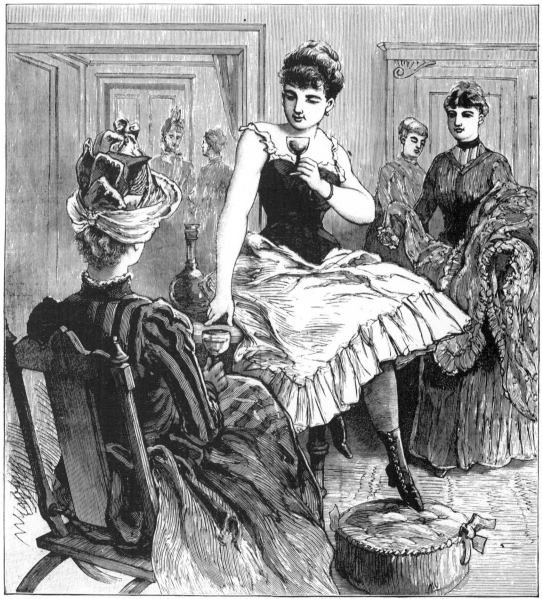

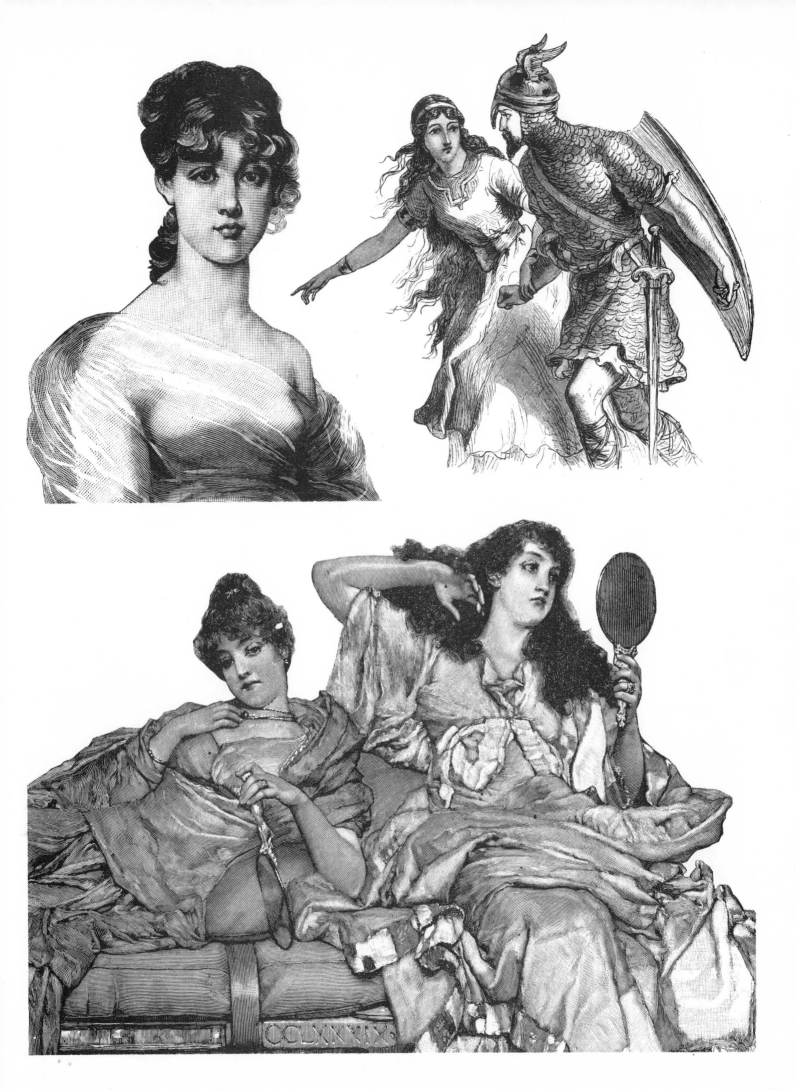

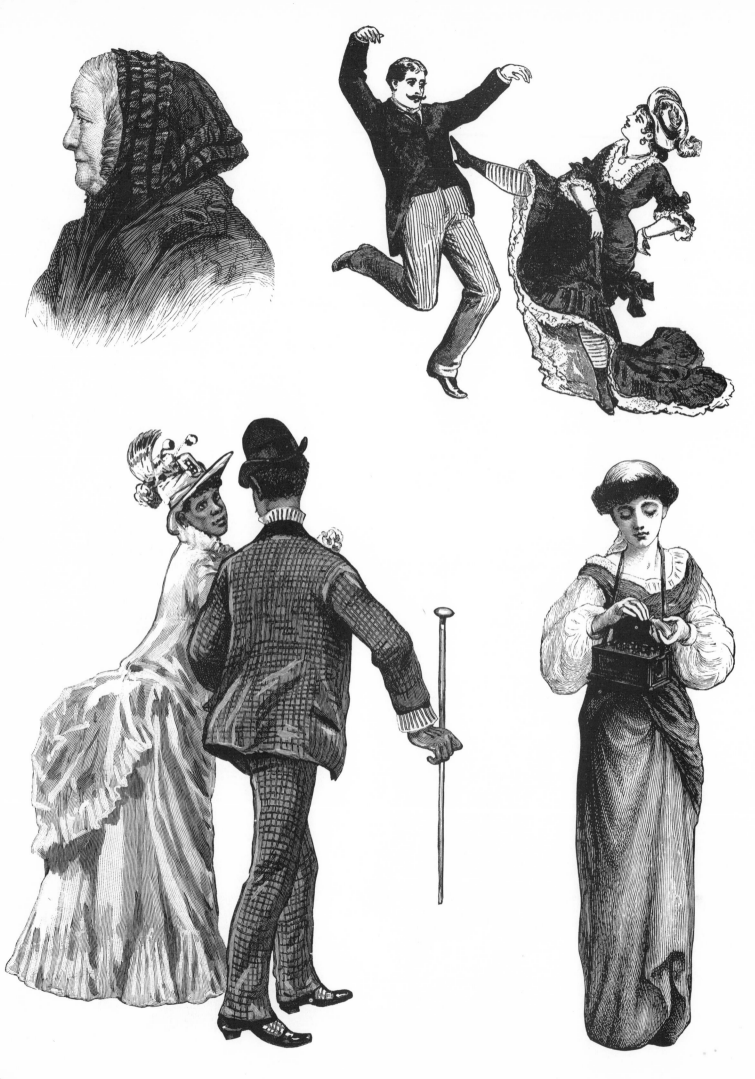

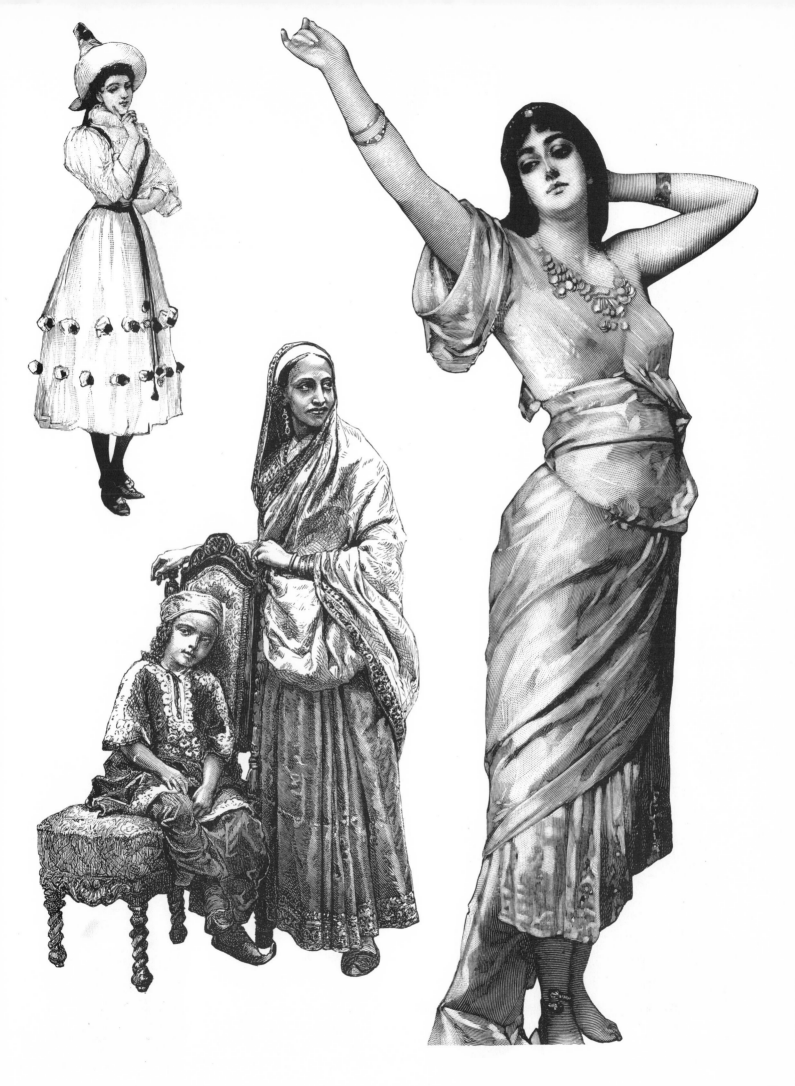

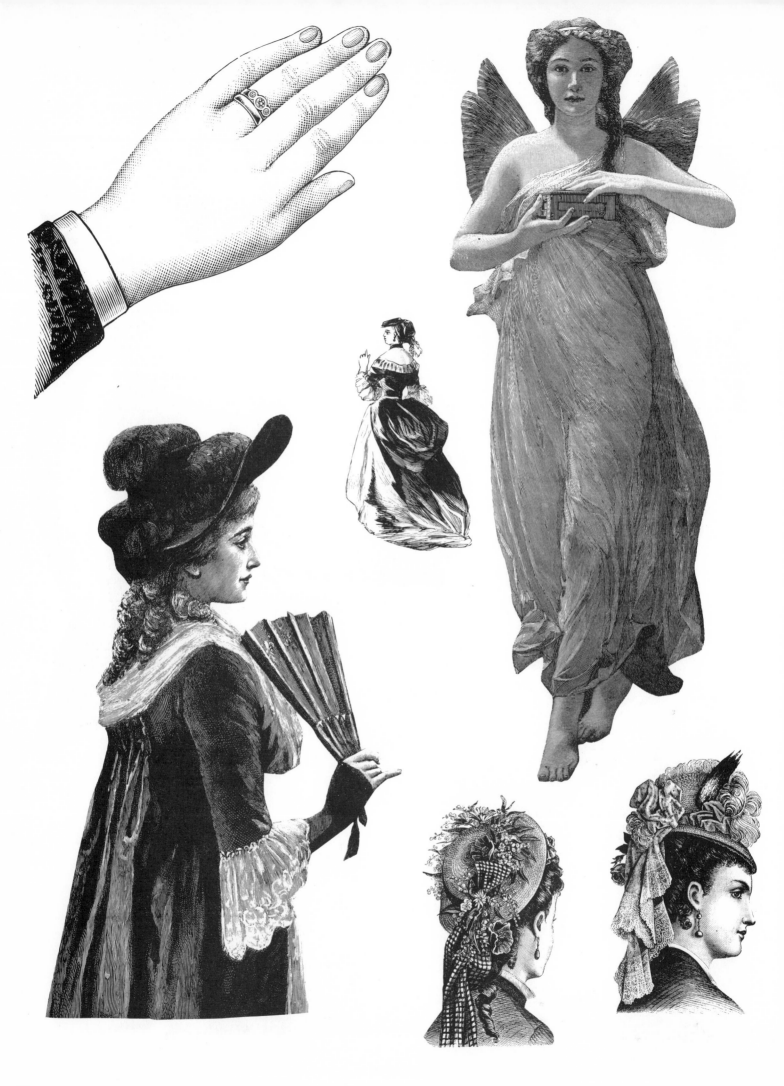

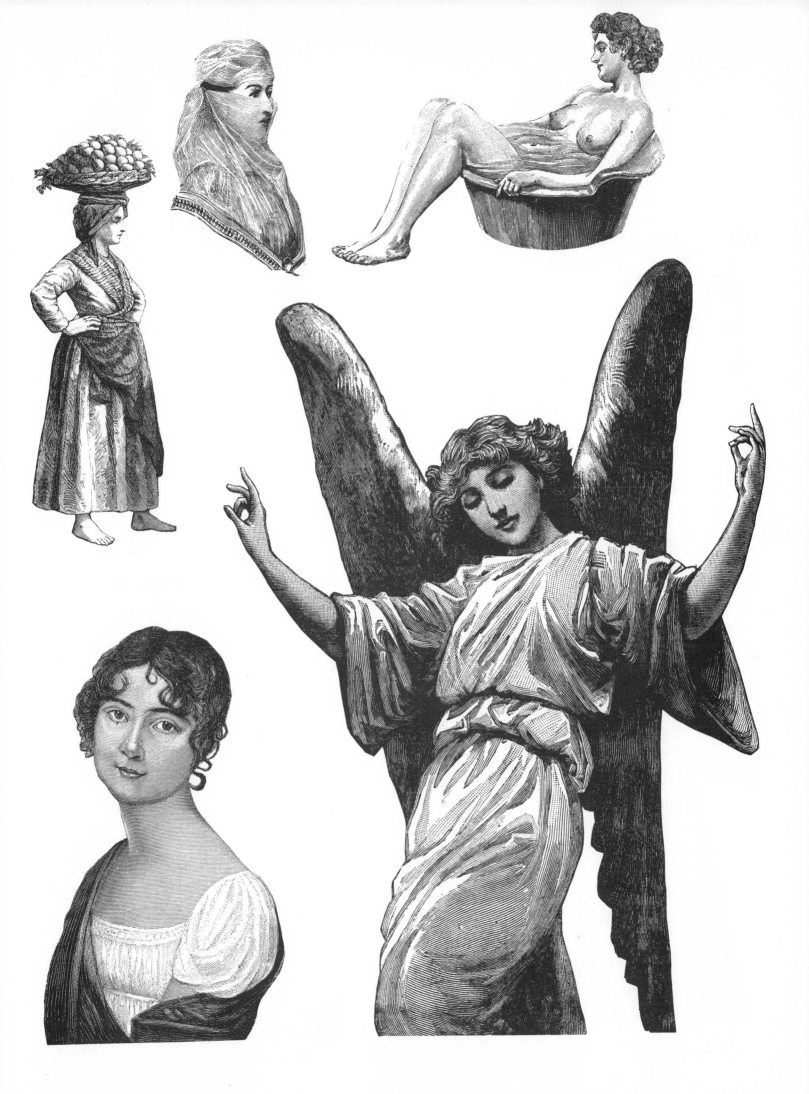

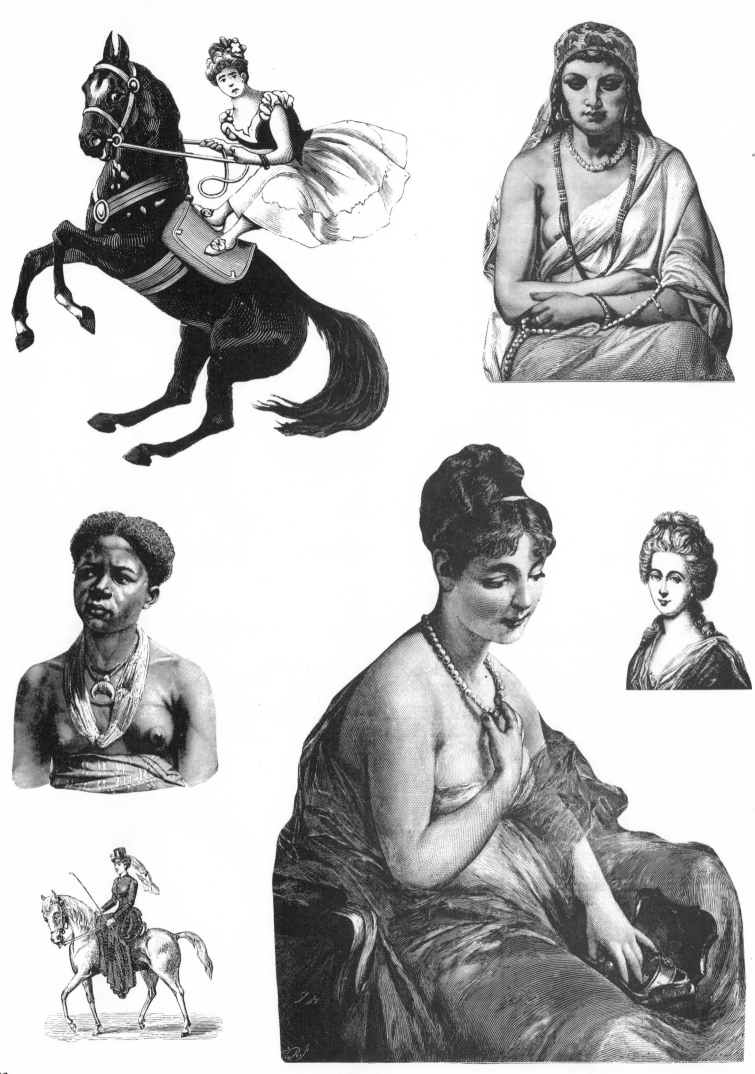

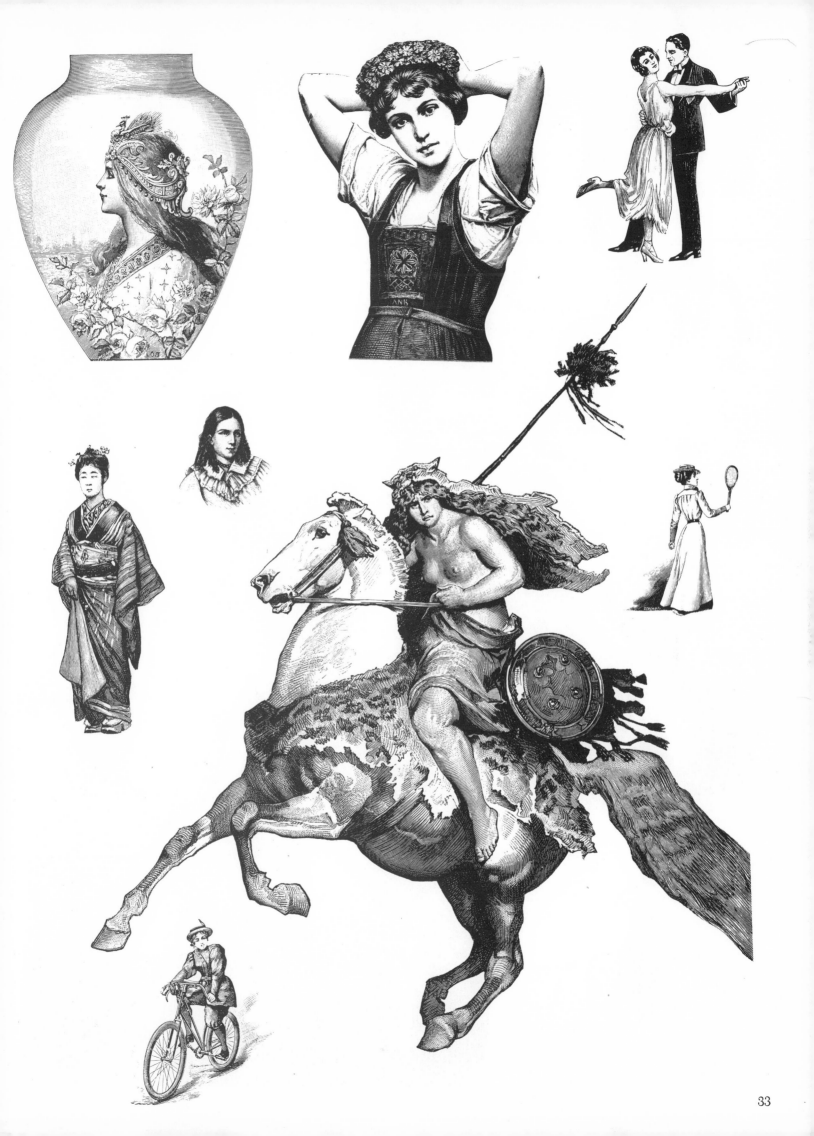

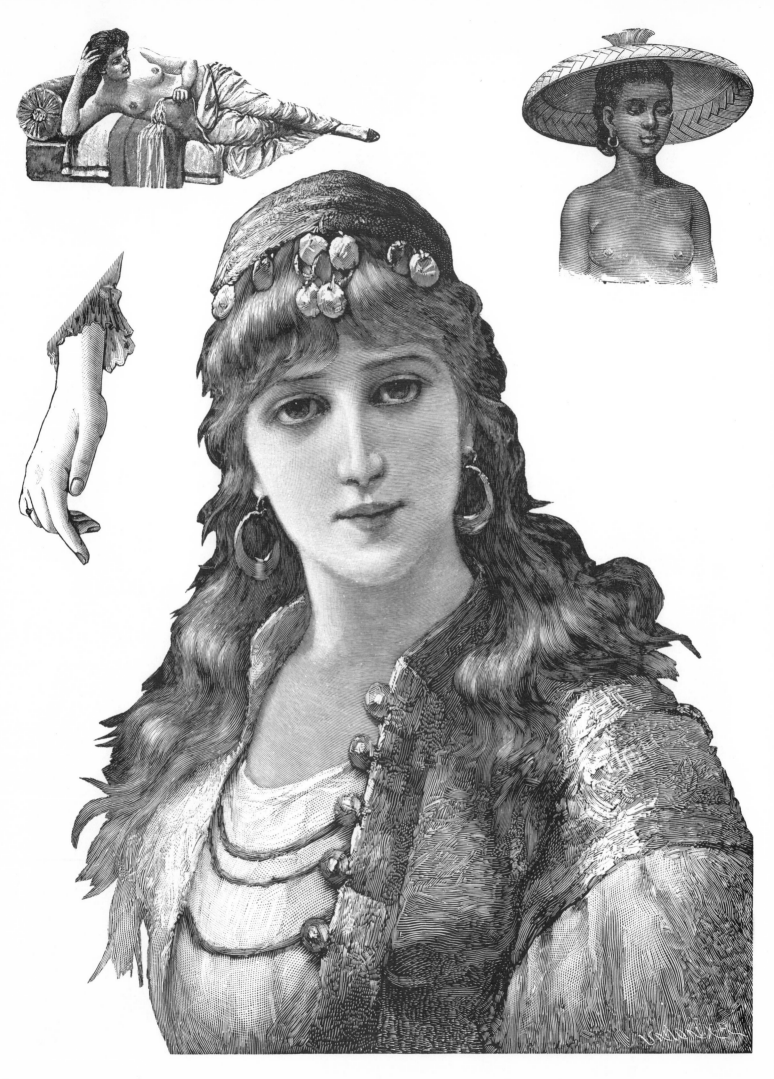

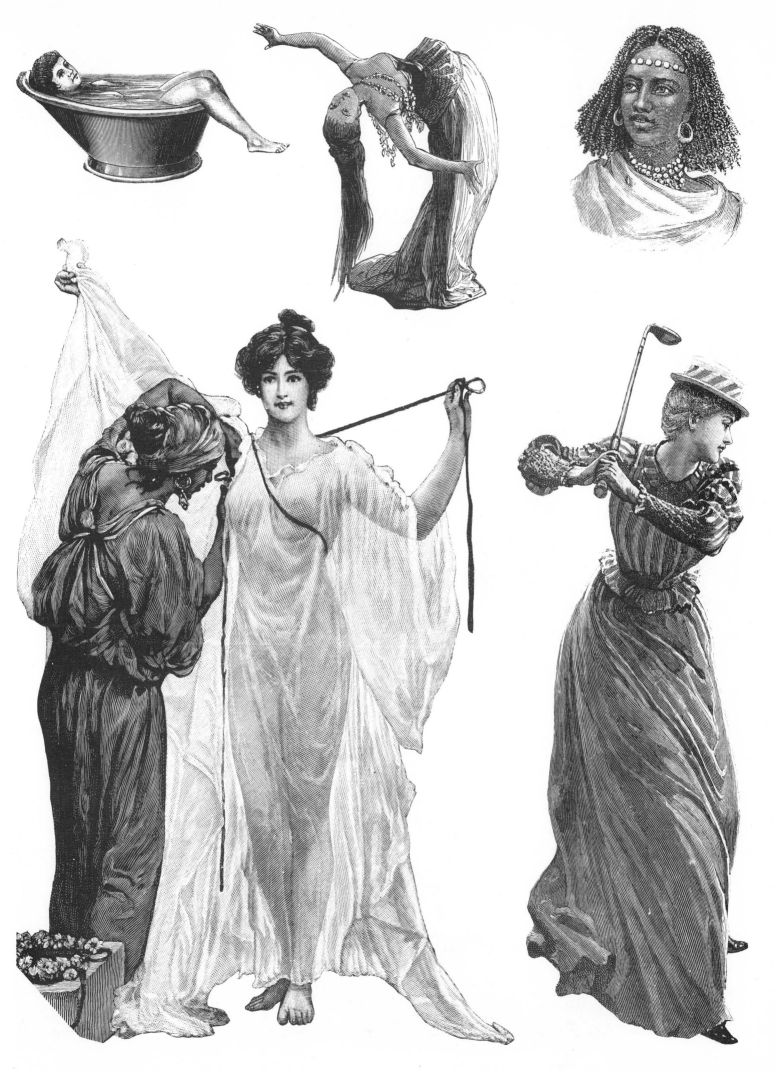

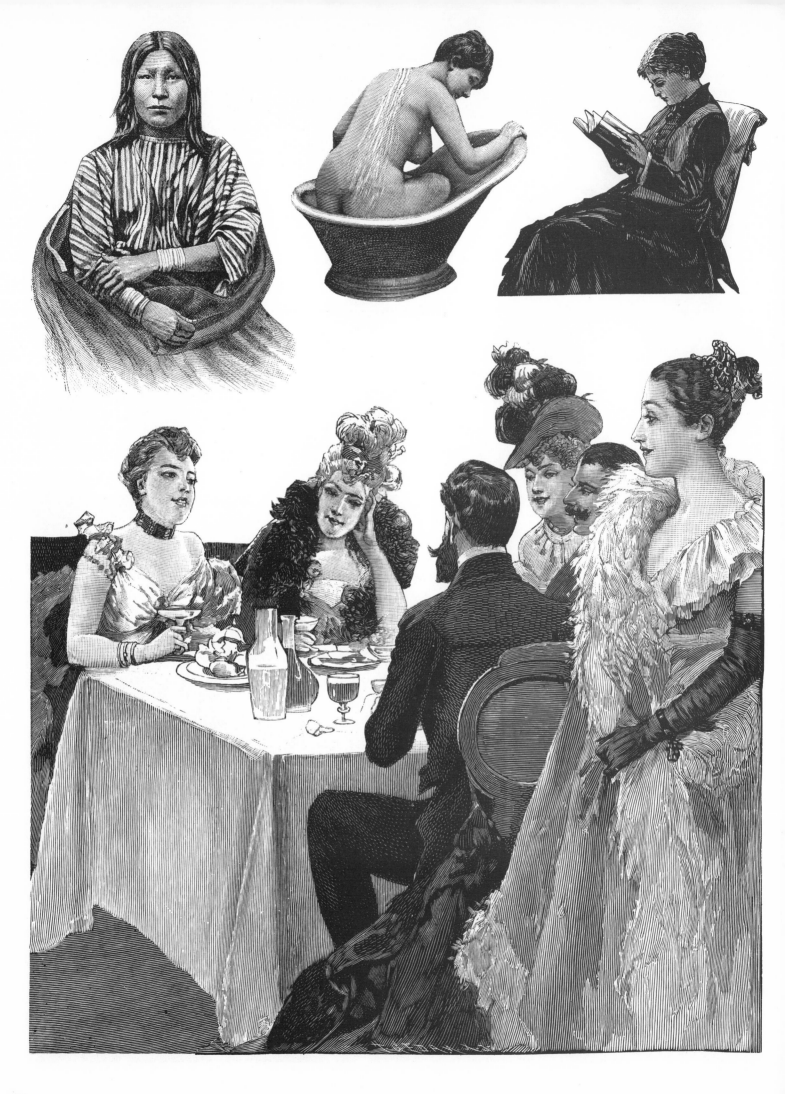

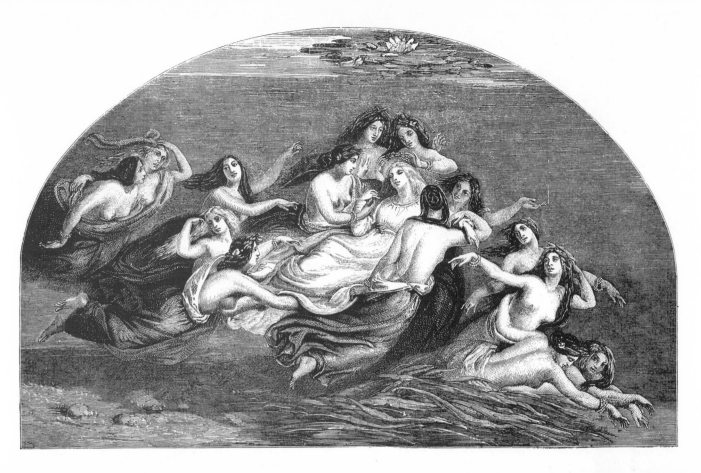

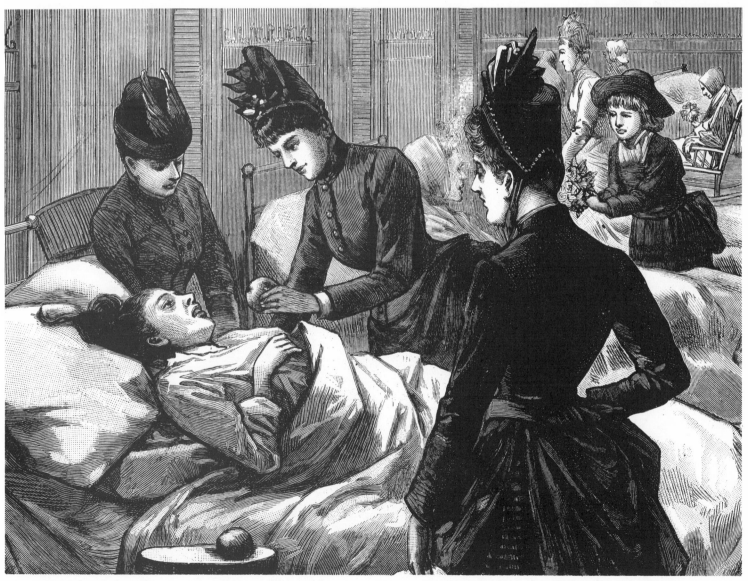

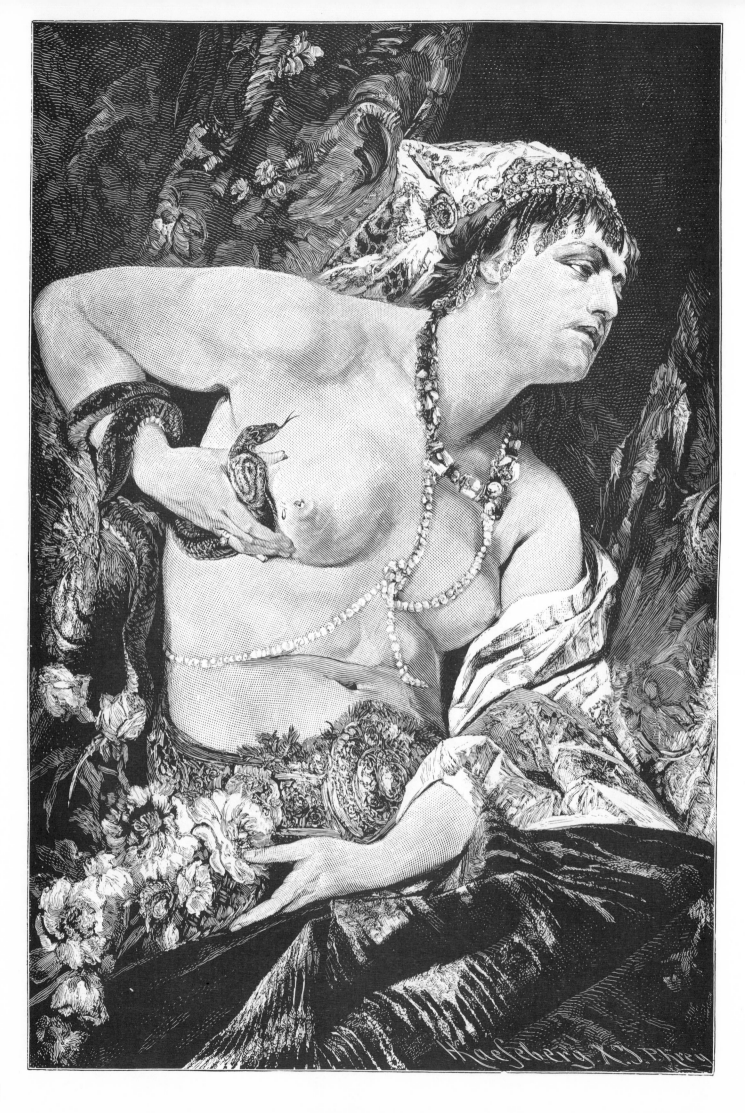

38

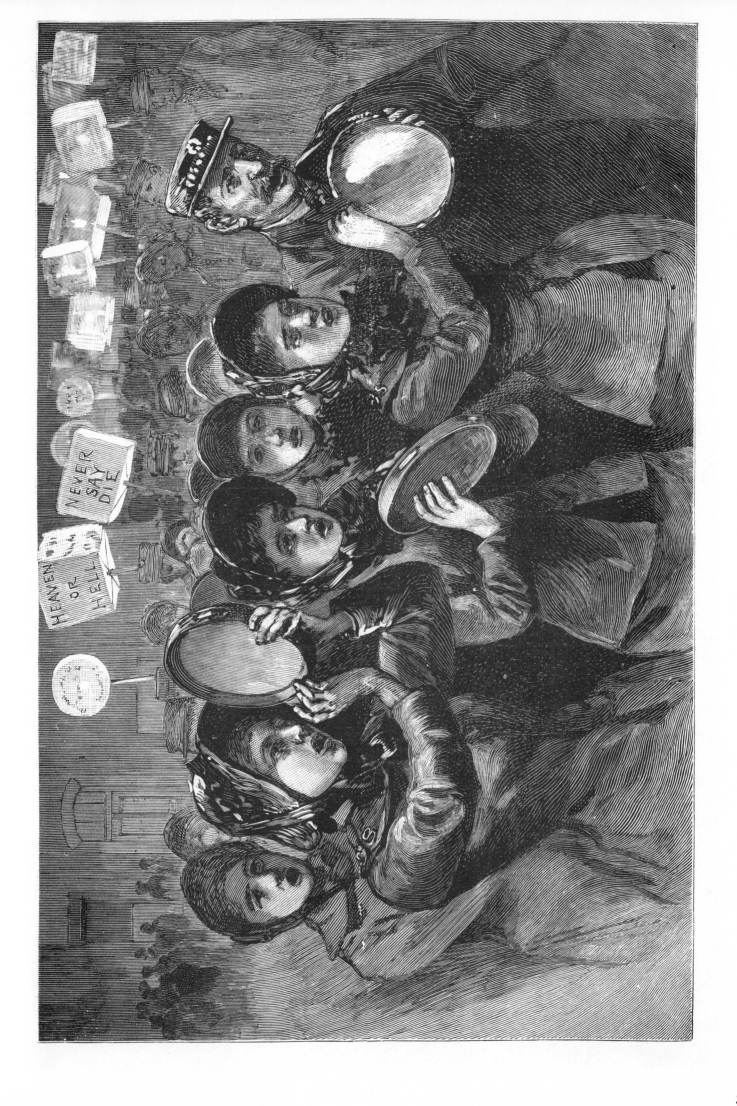

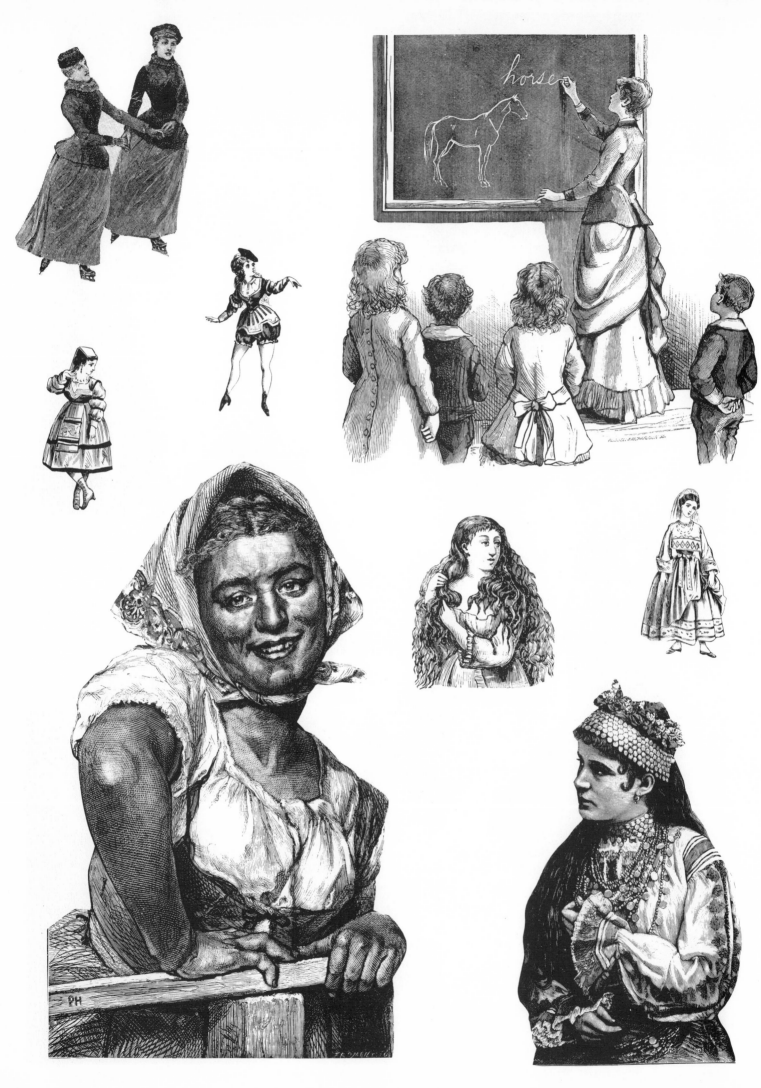

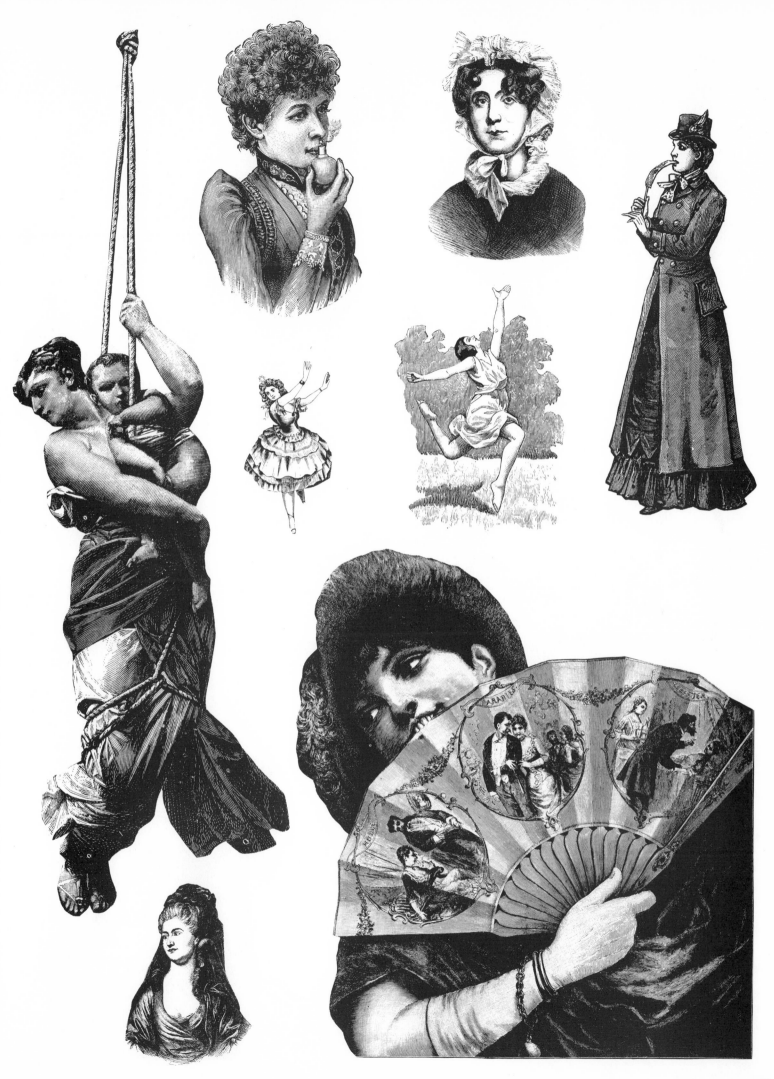

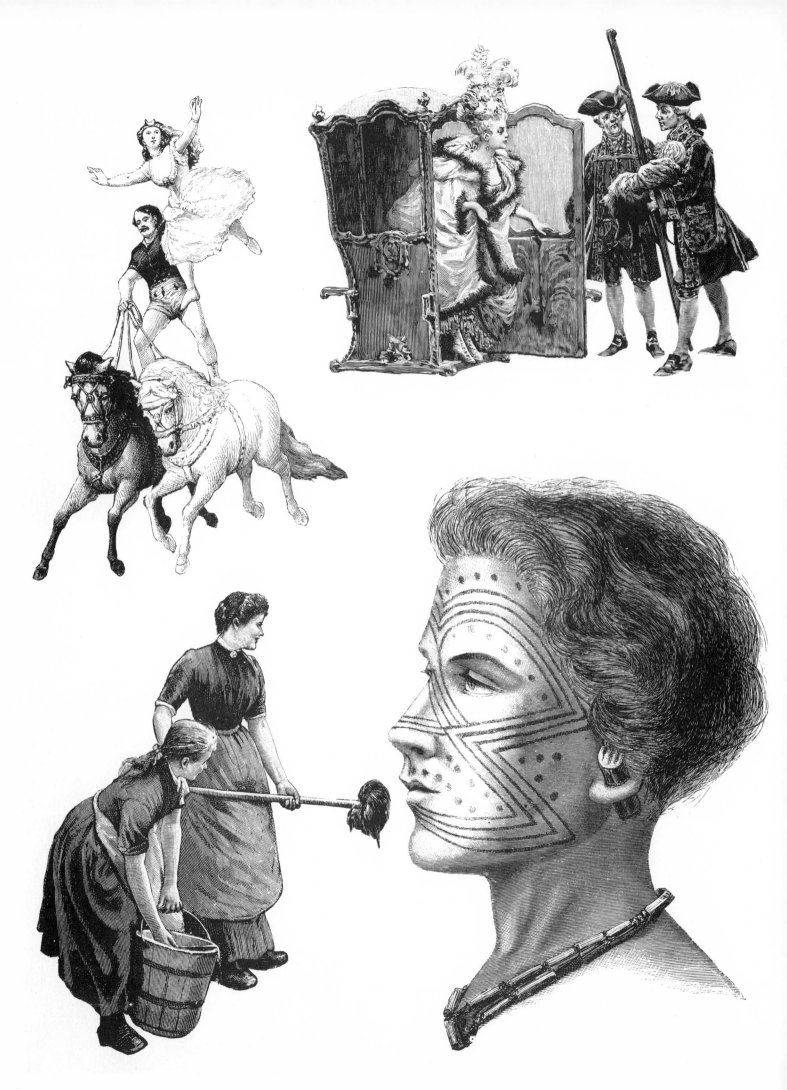

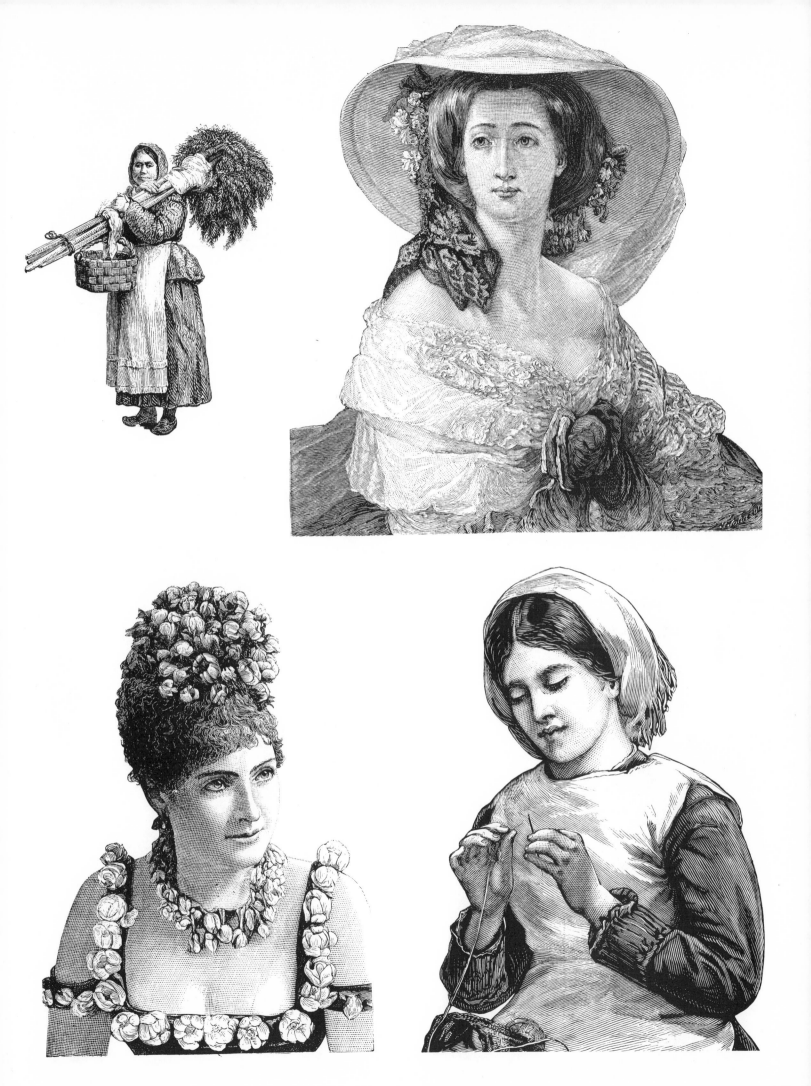

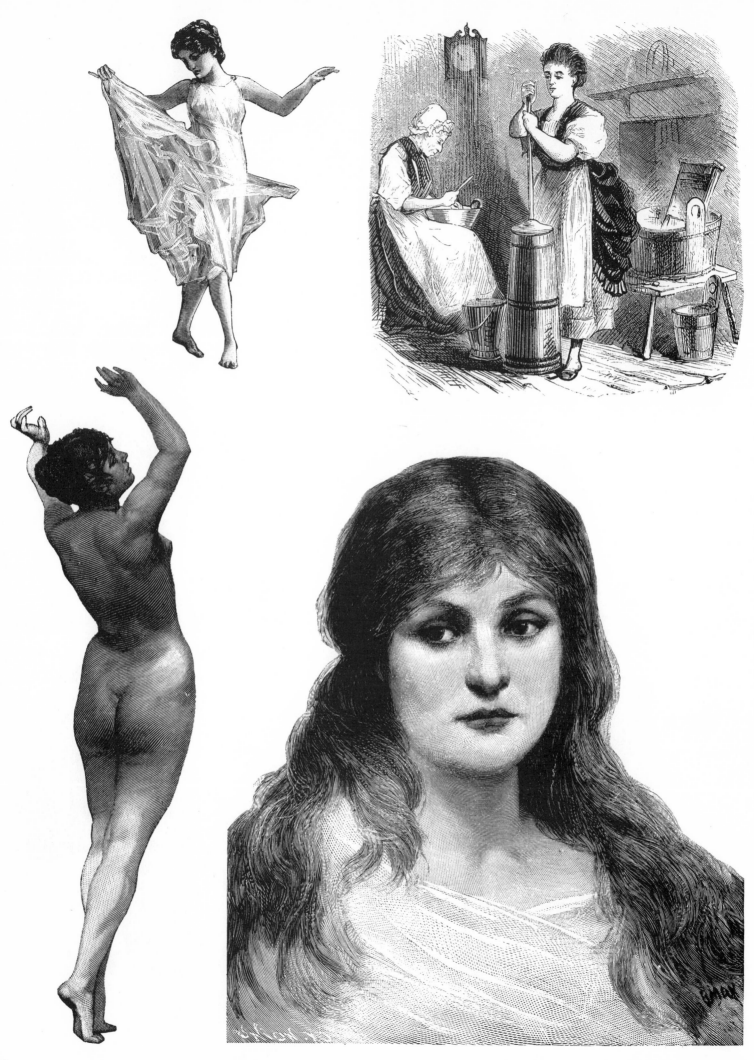

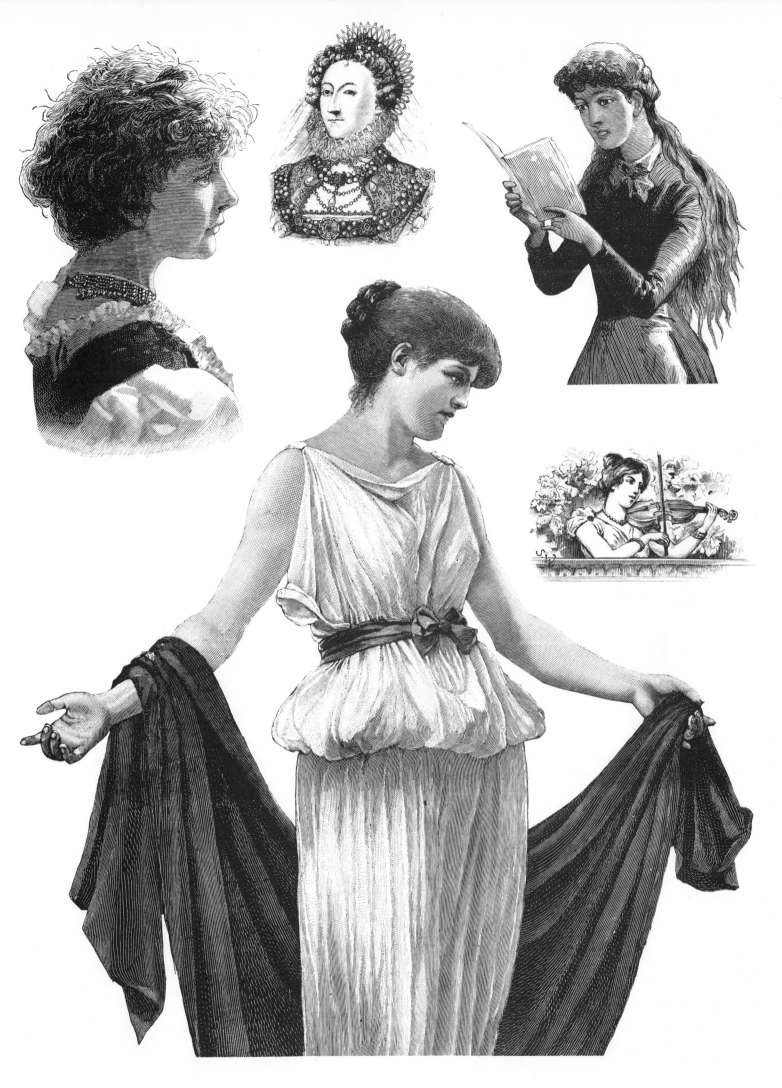

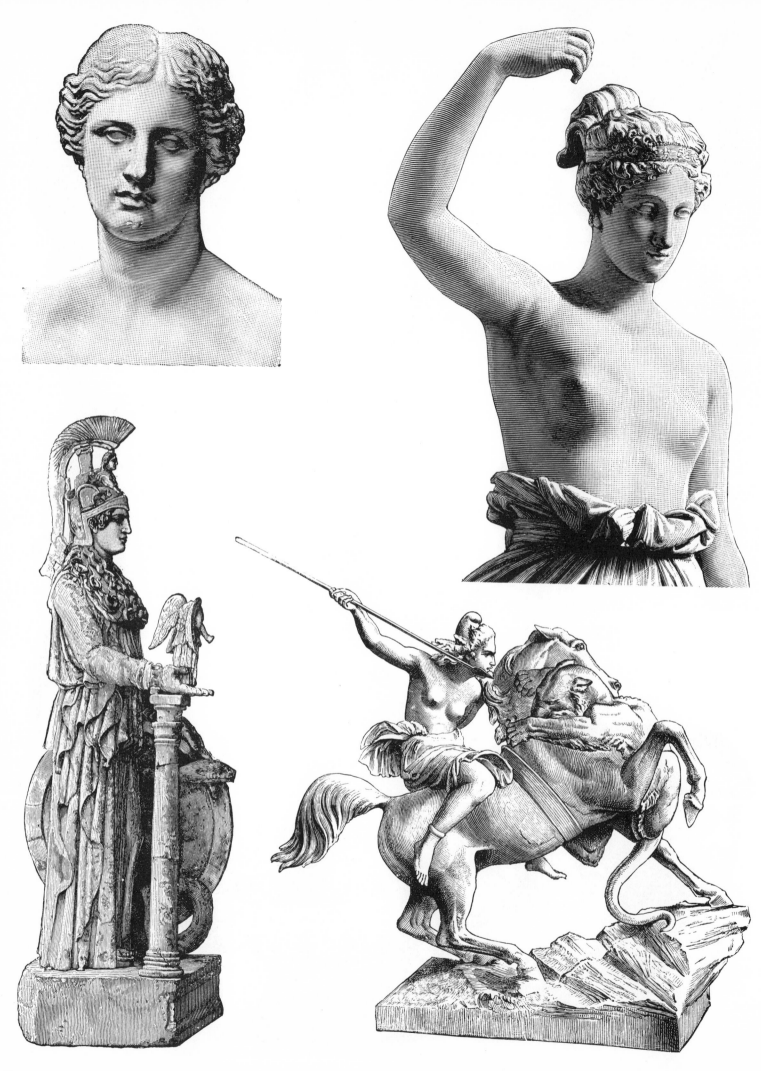

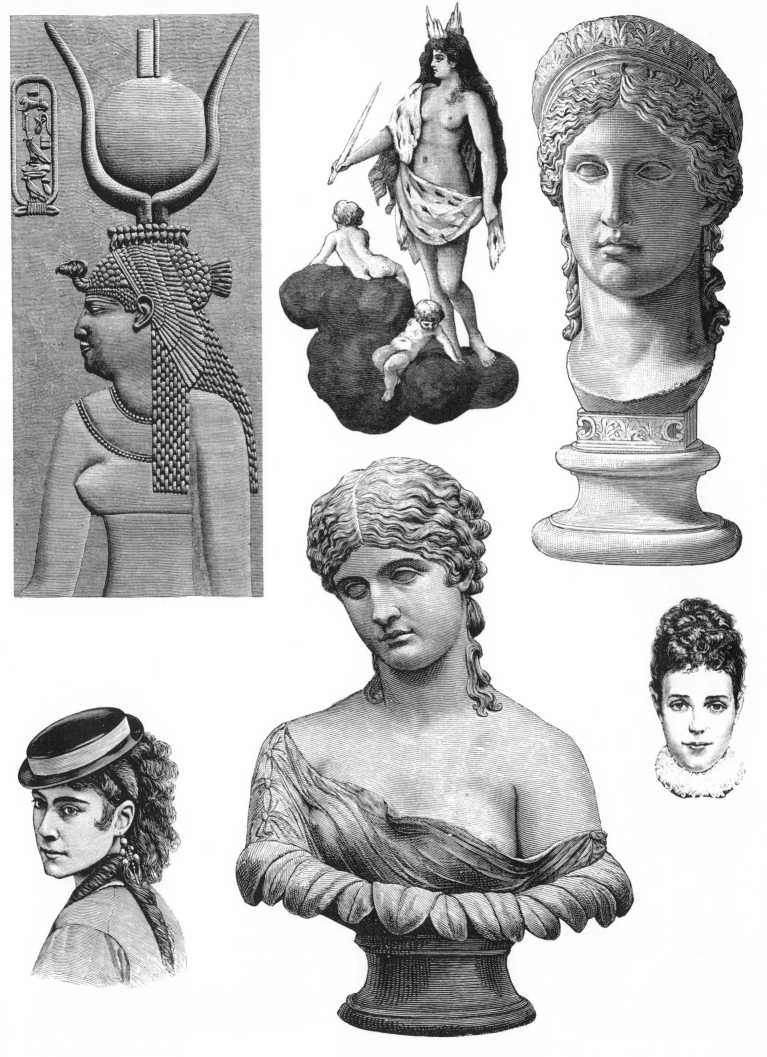

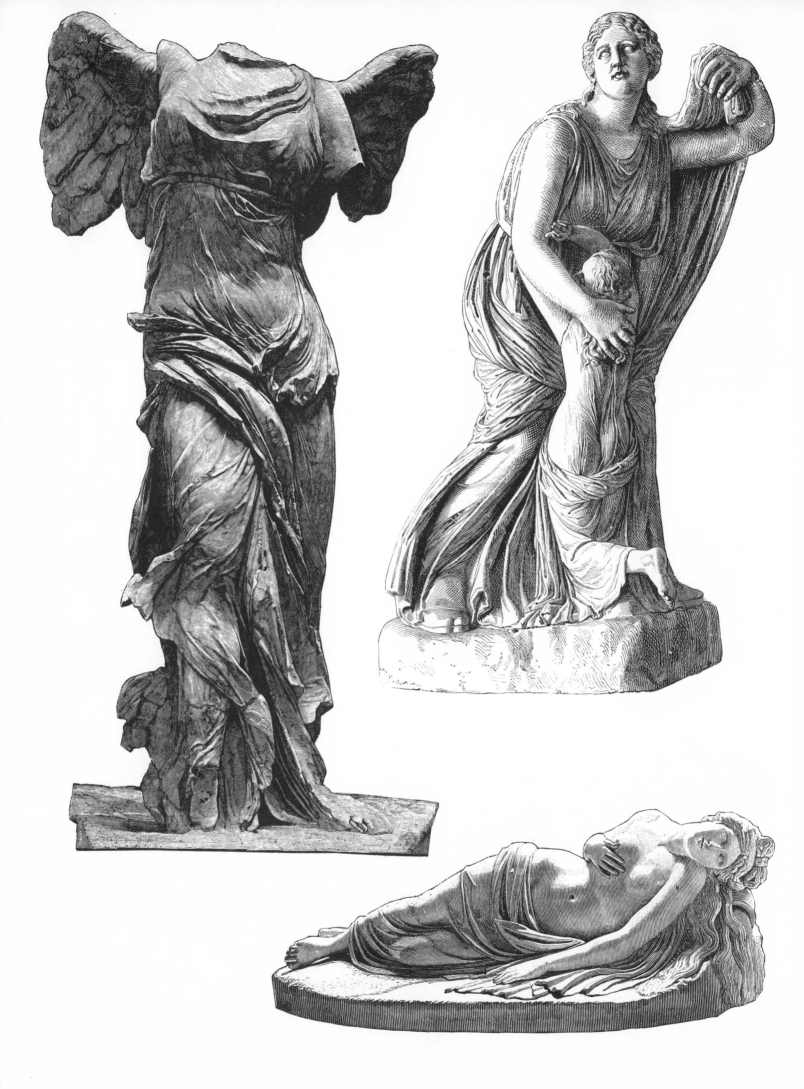

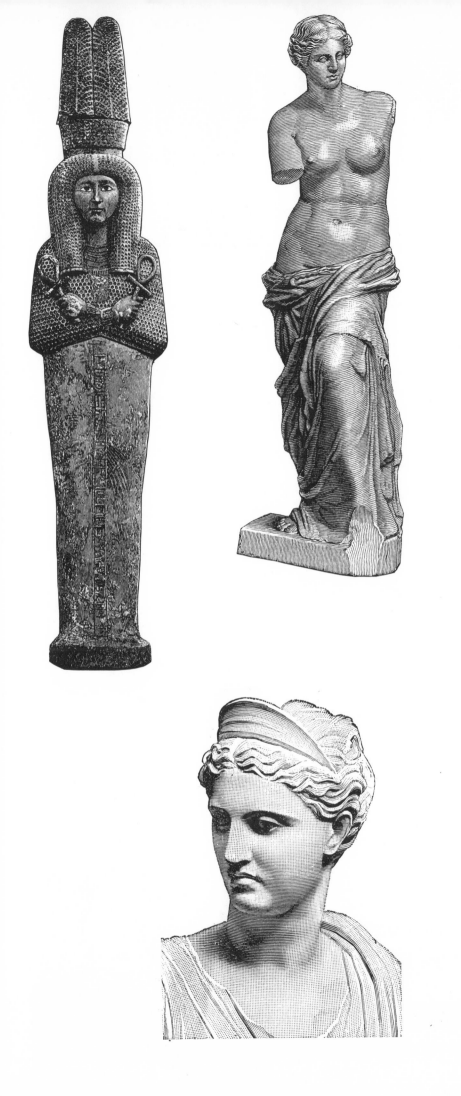

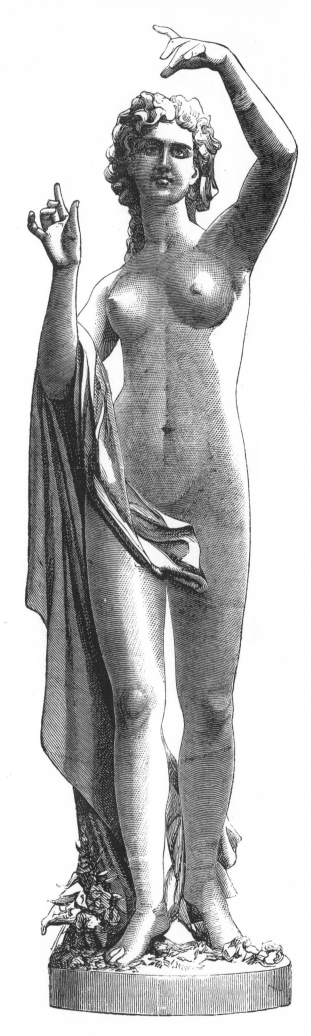

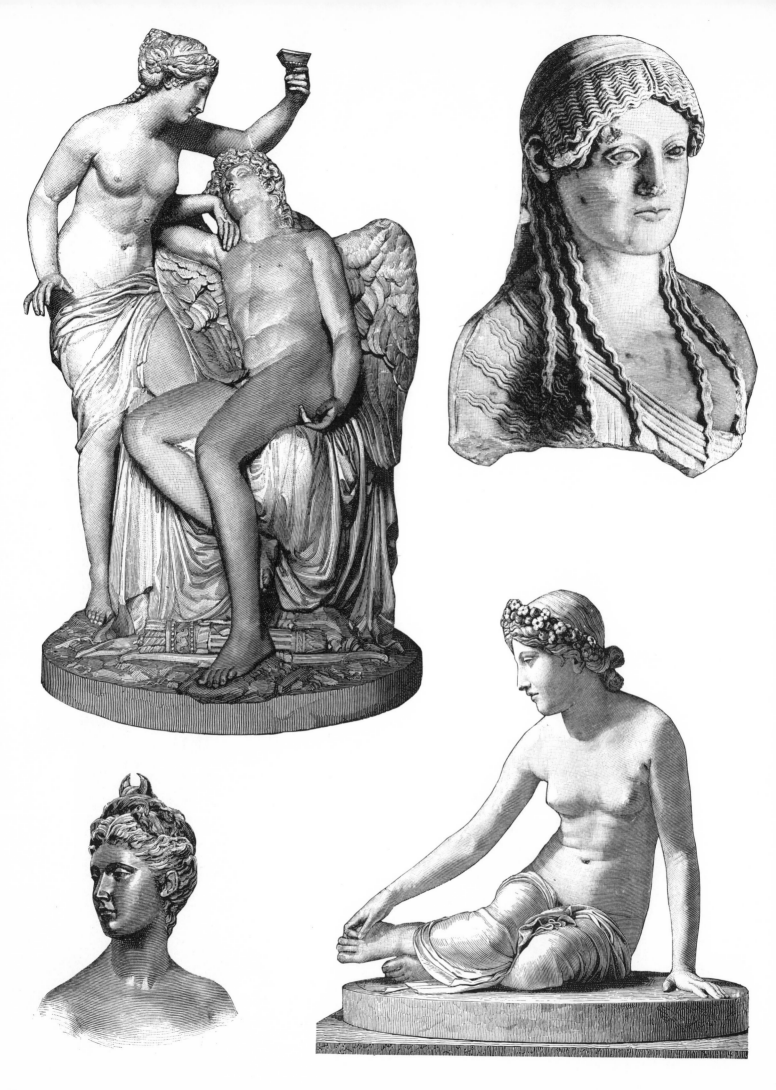

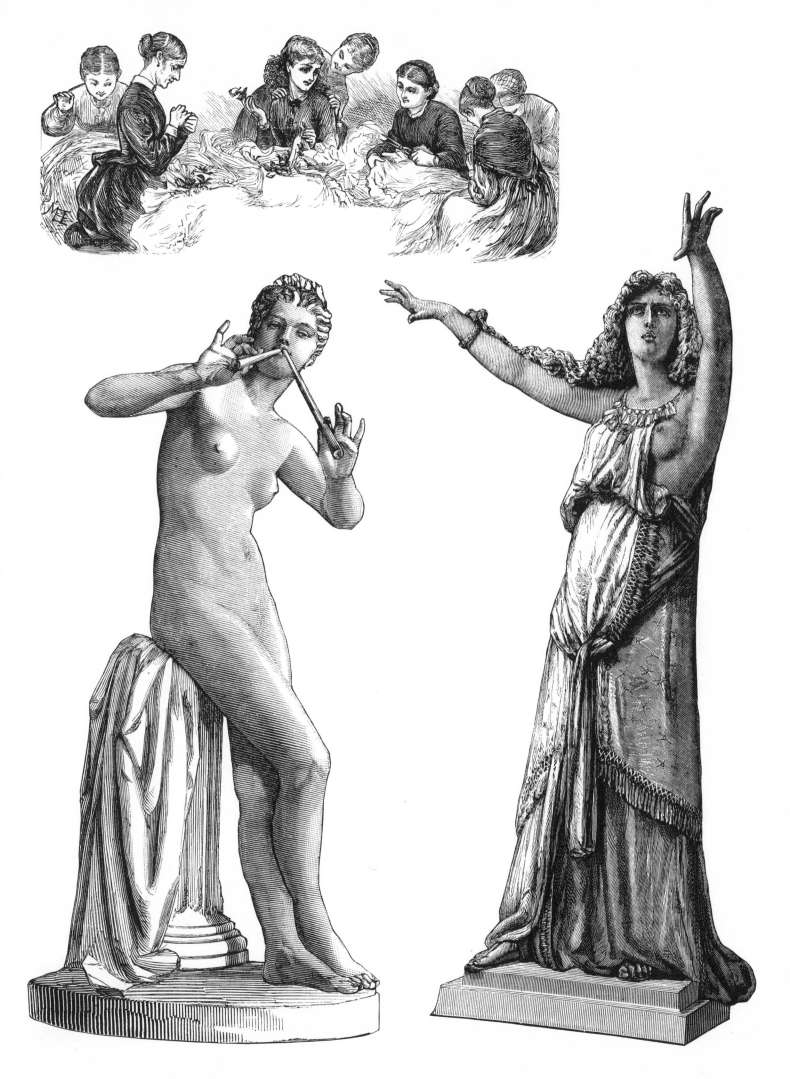

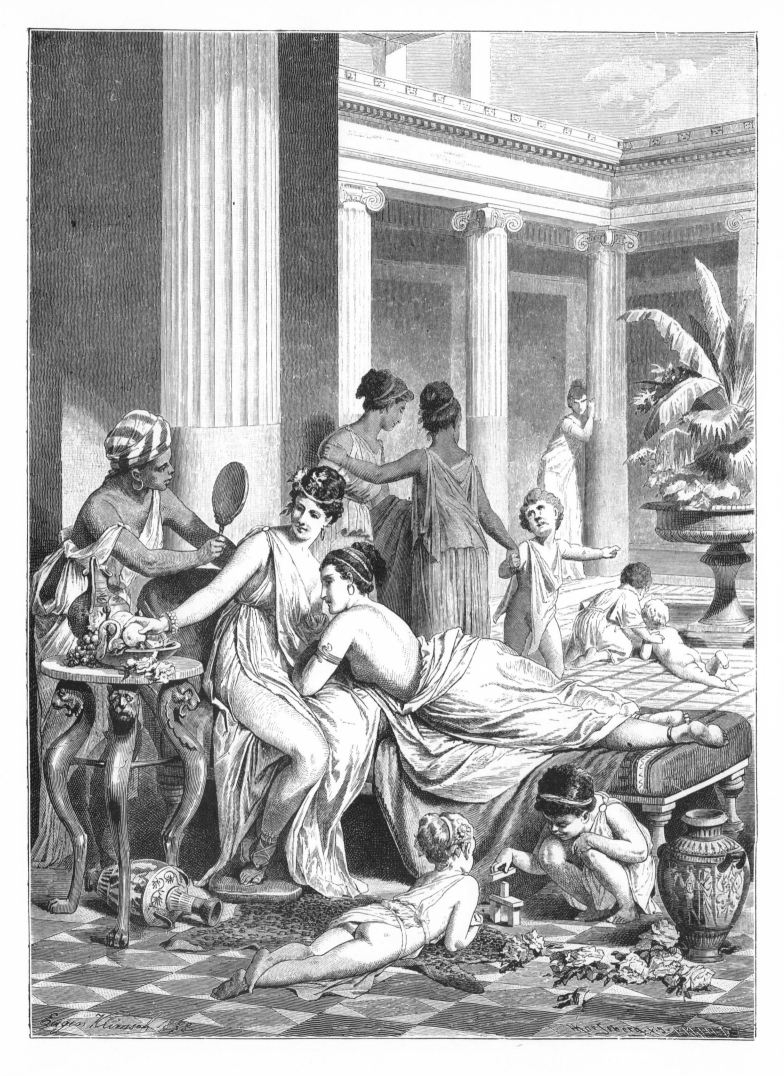

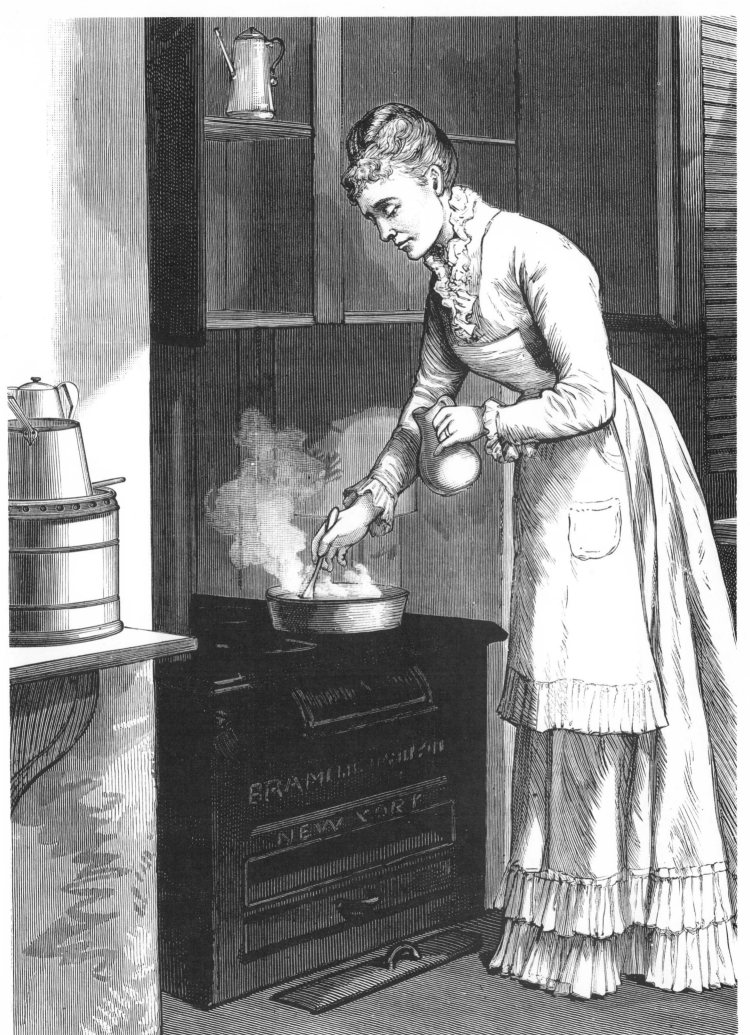

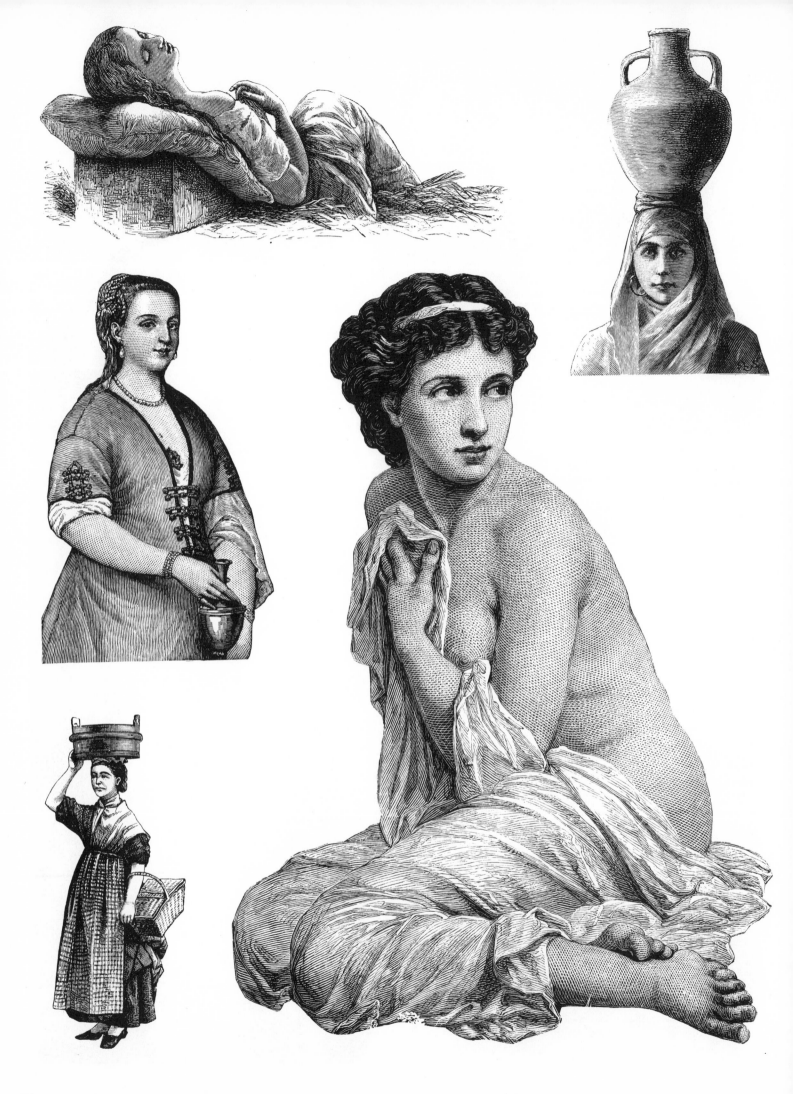

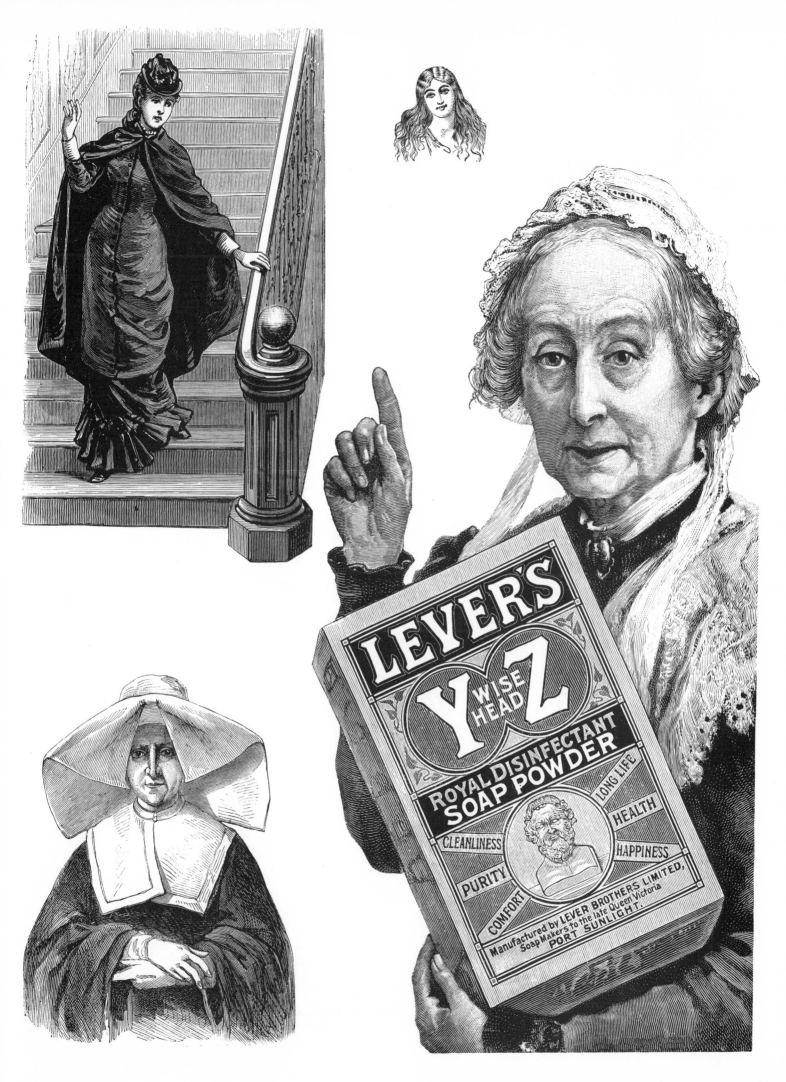

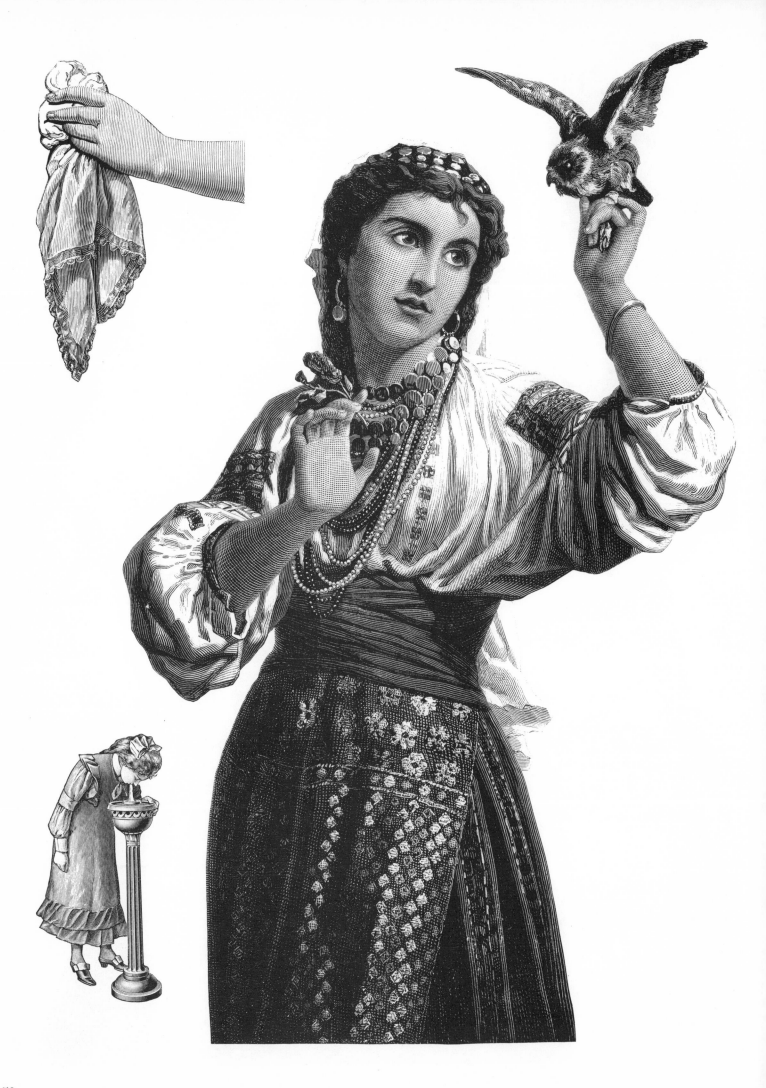

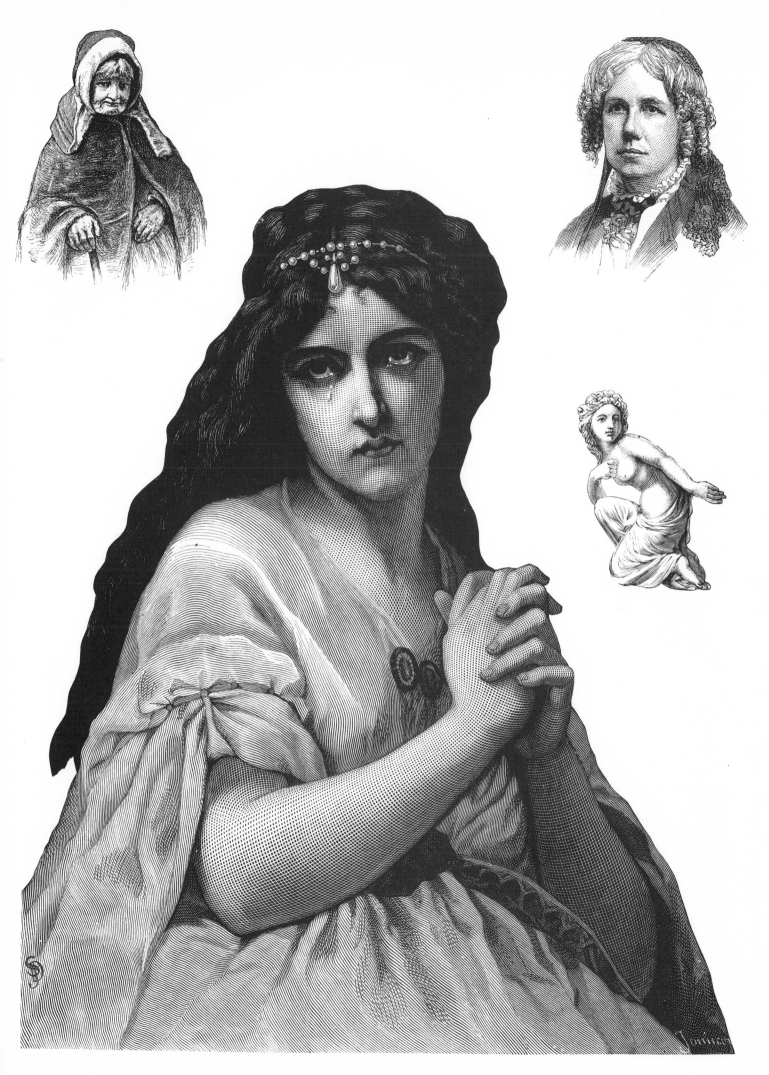

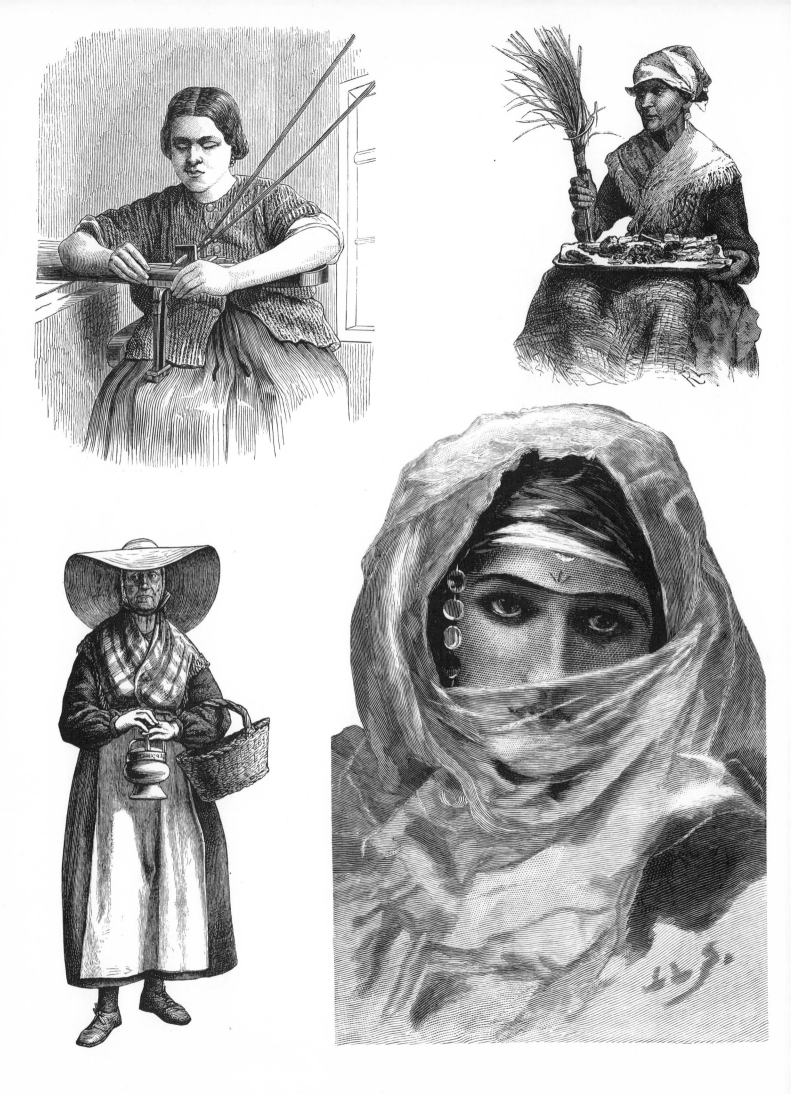

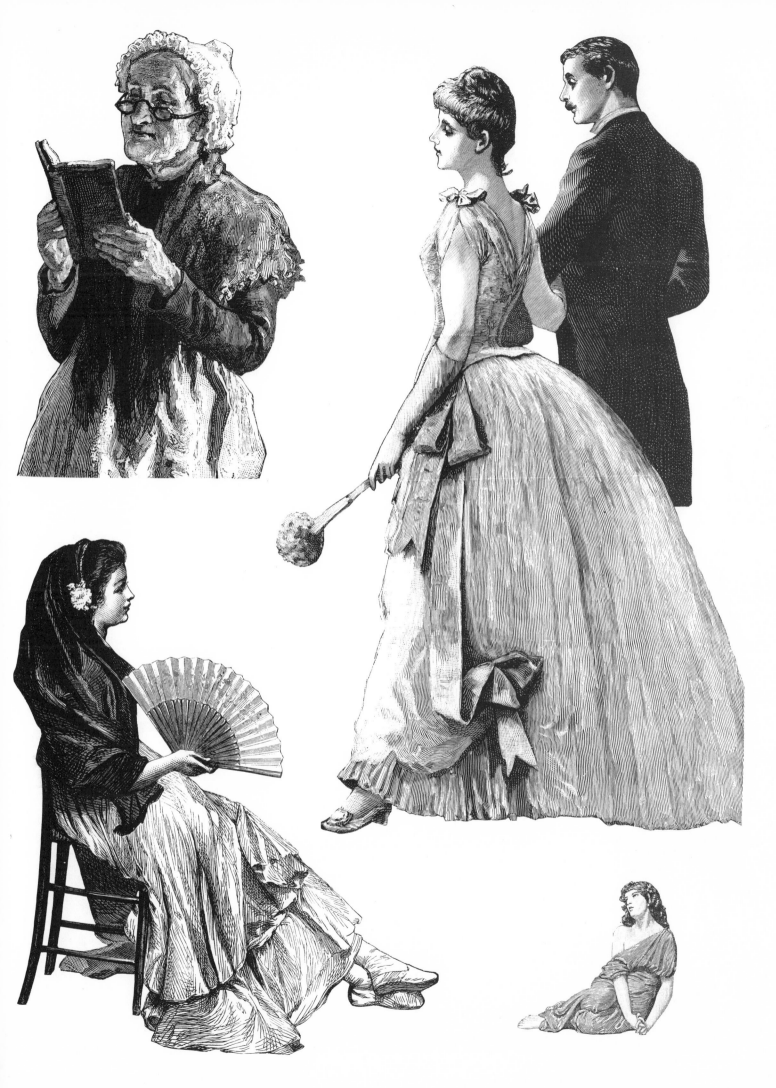

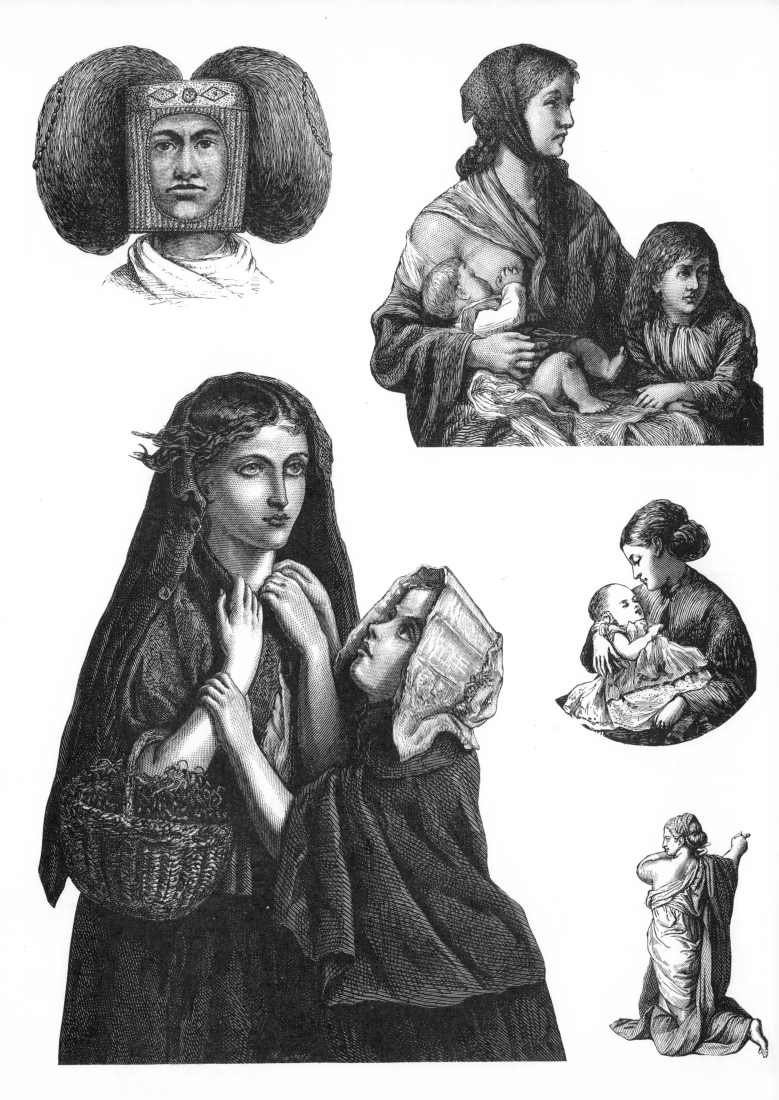

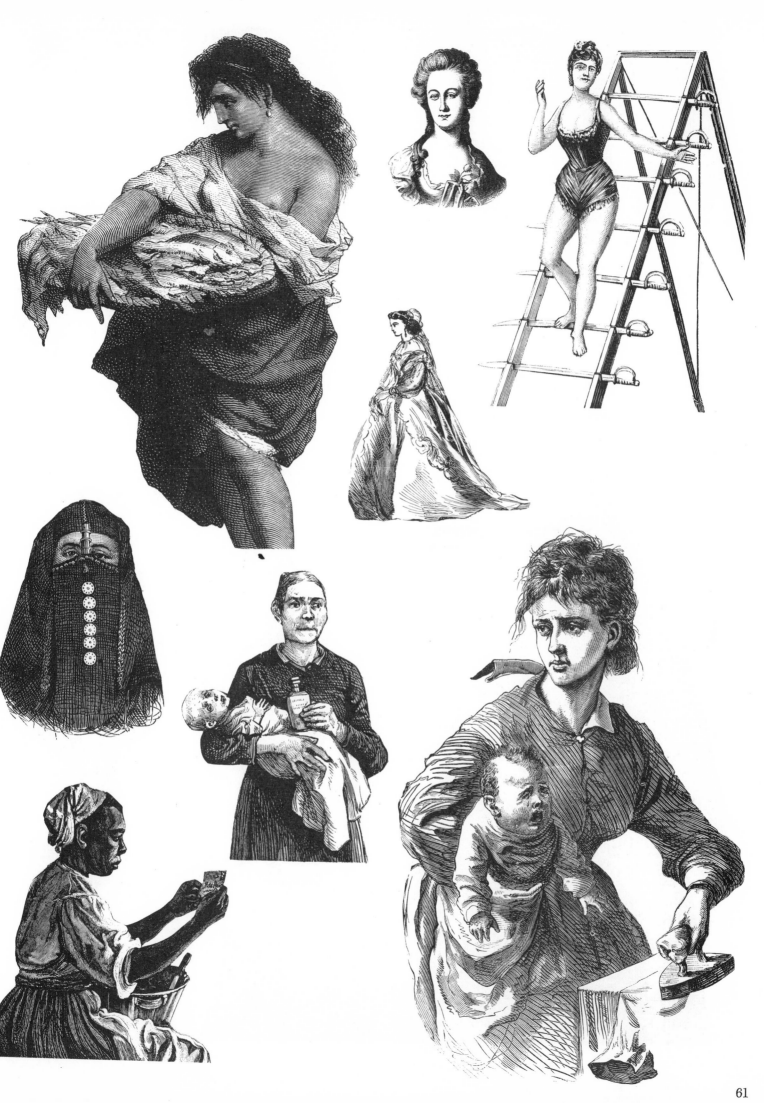

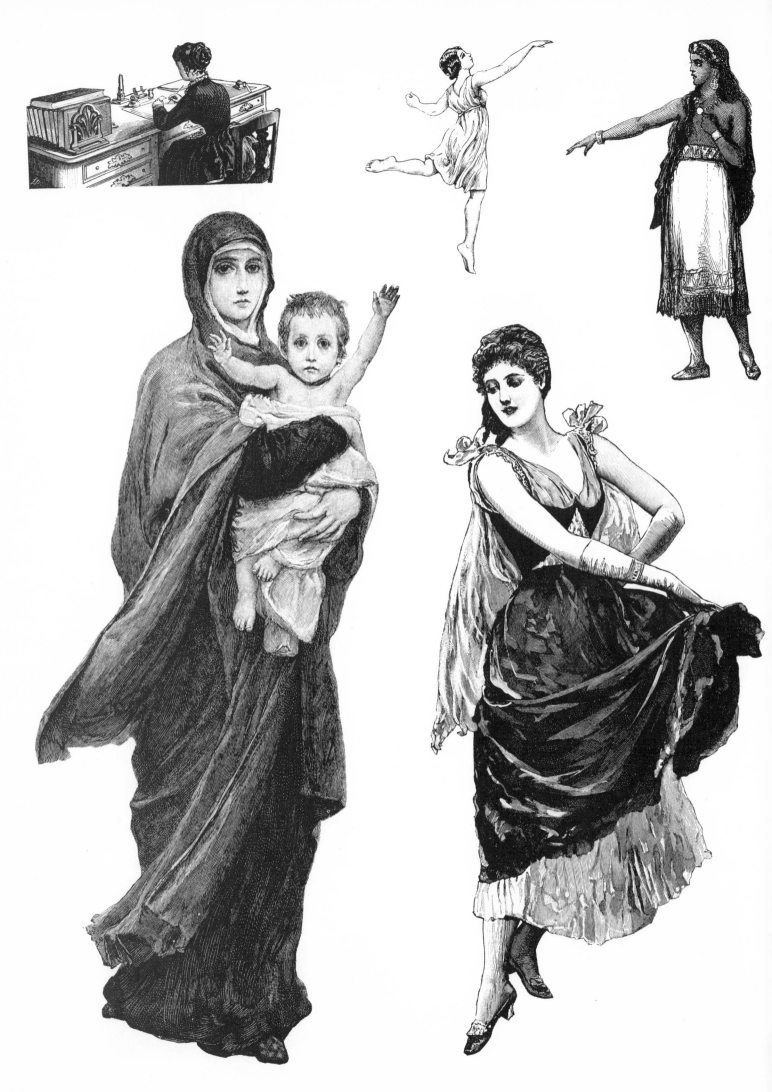

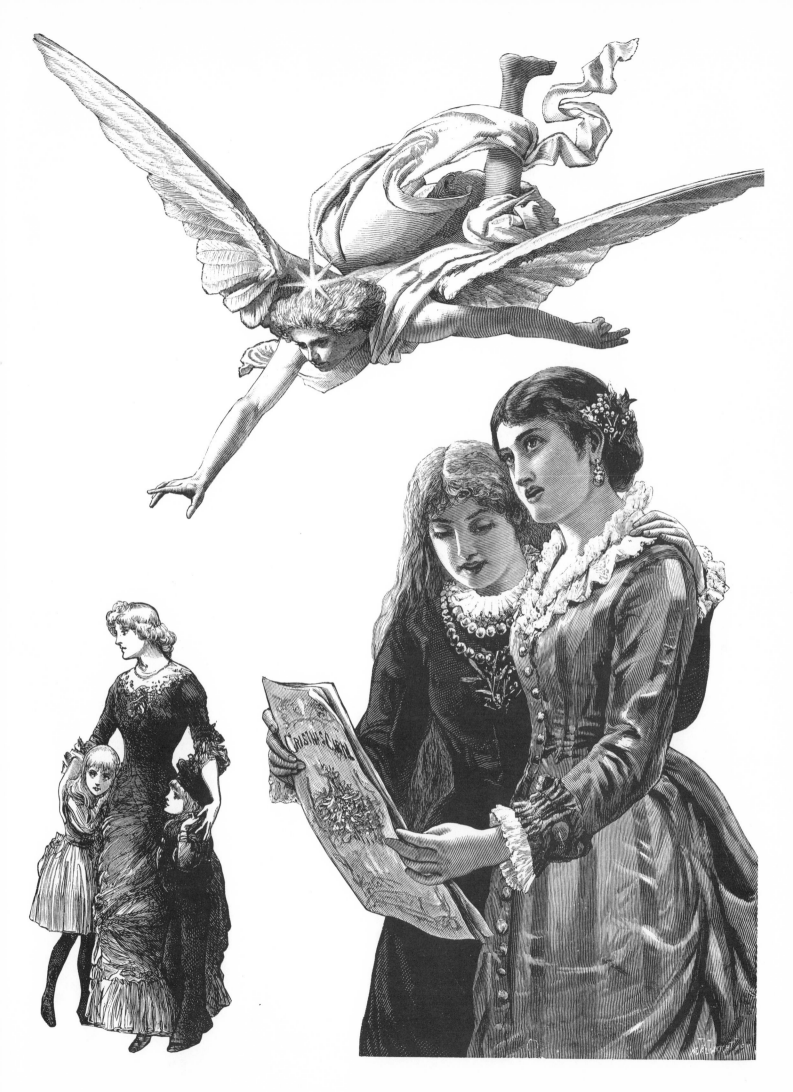

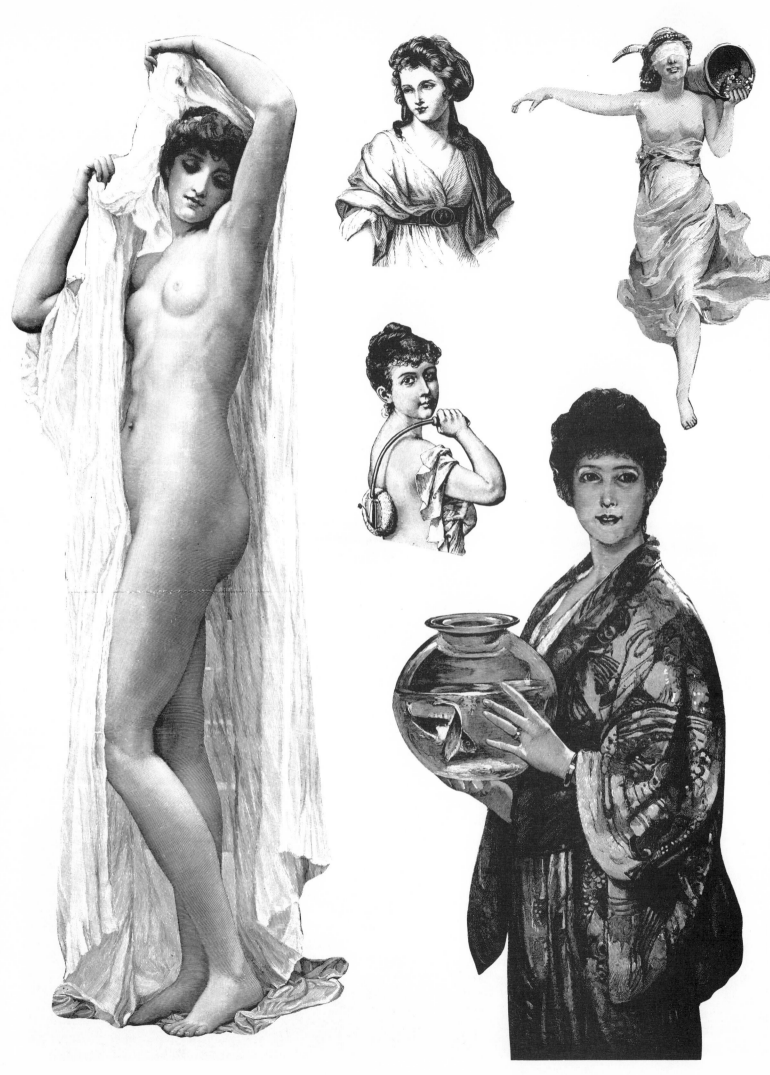

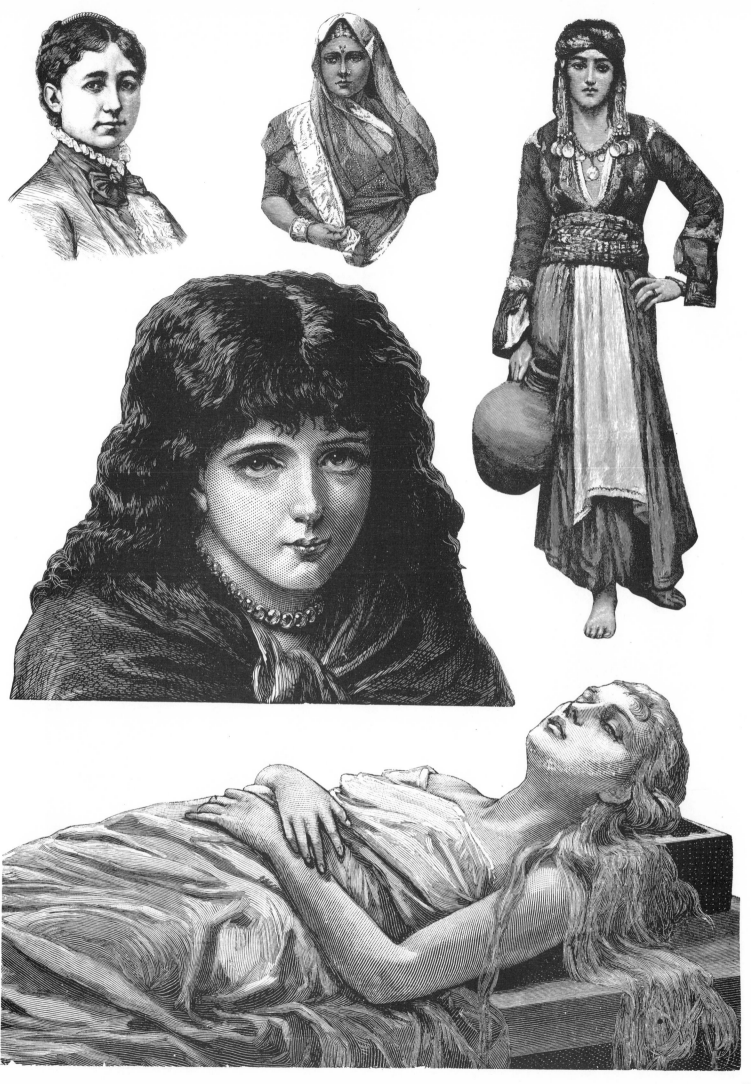

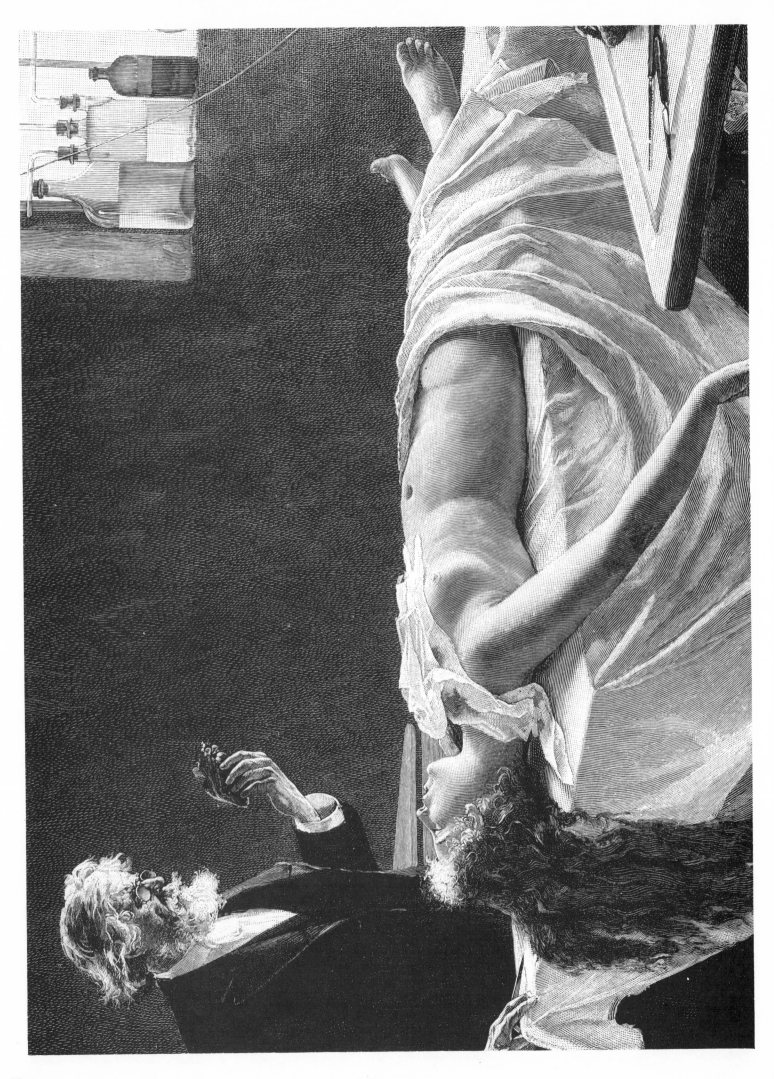

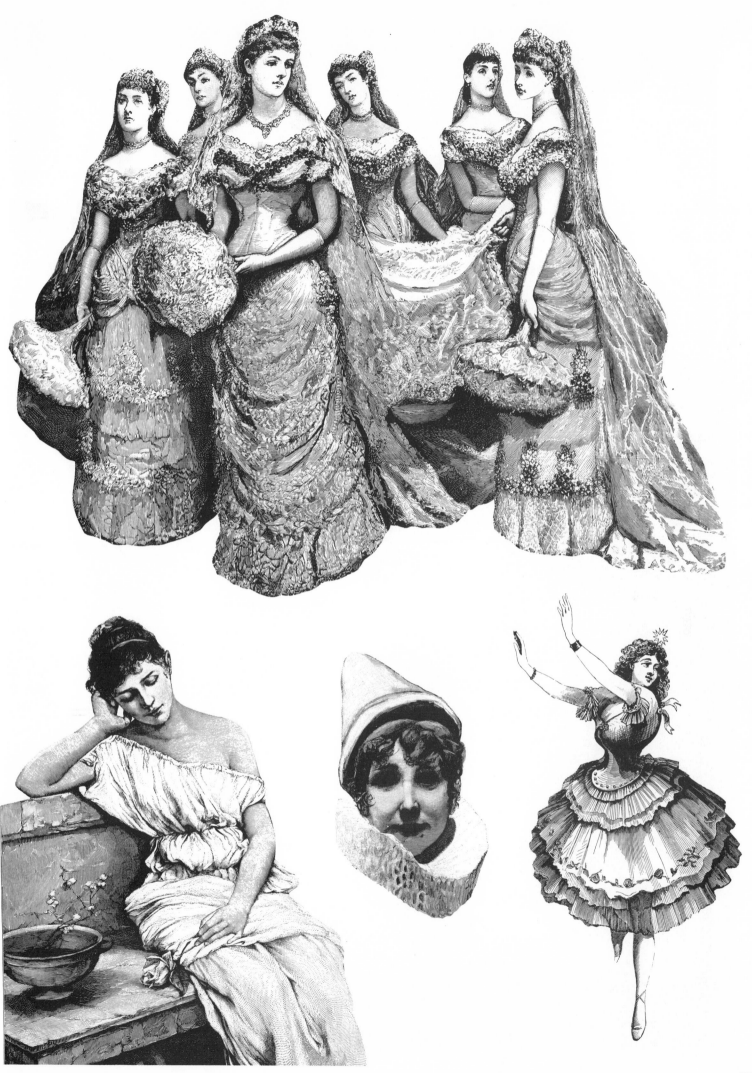

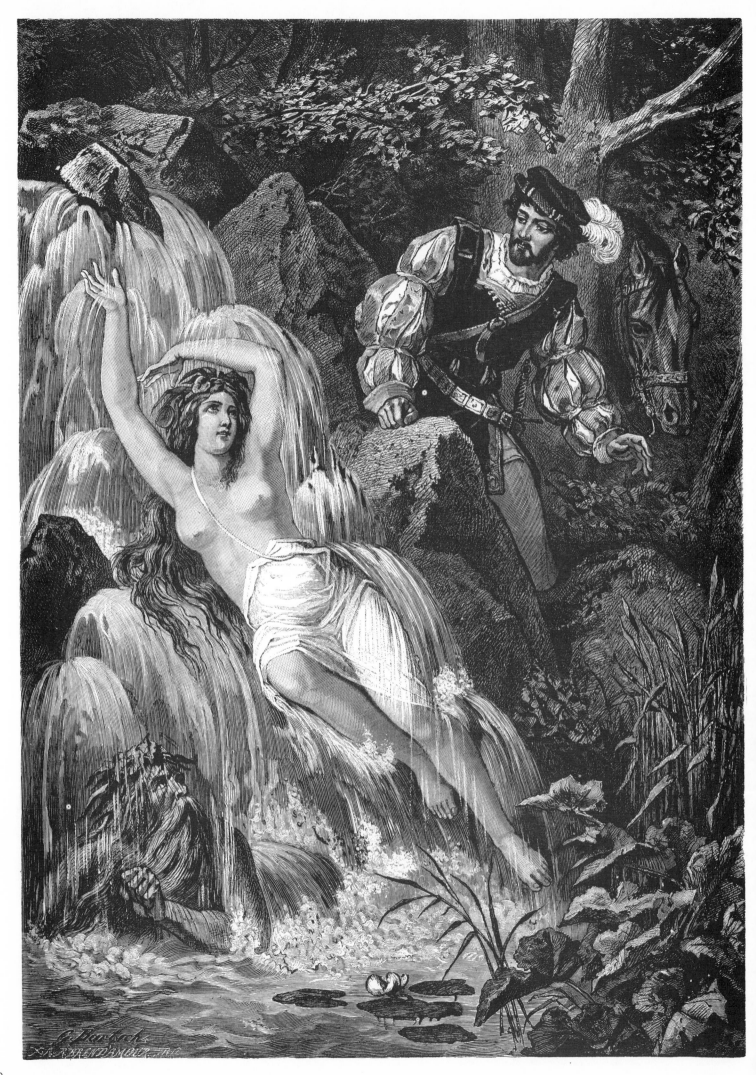

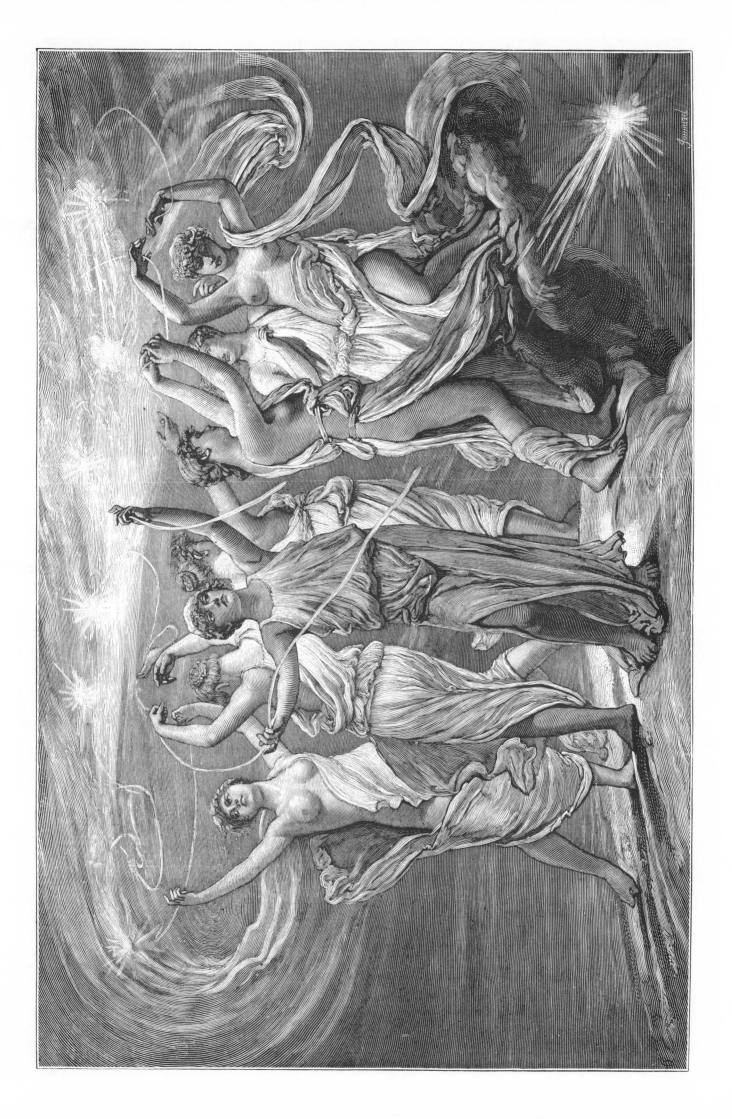

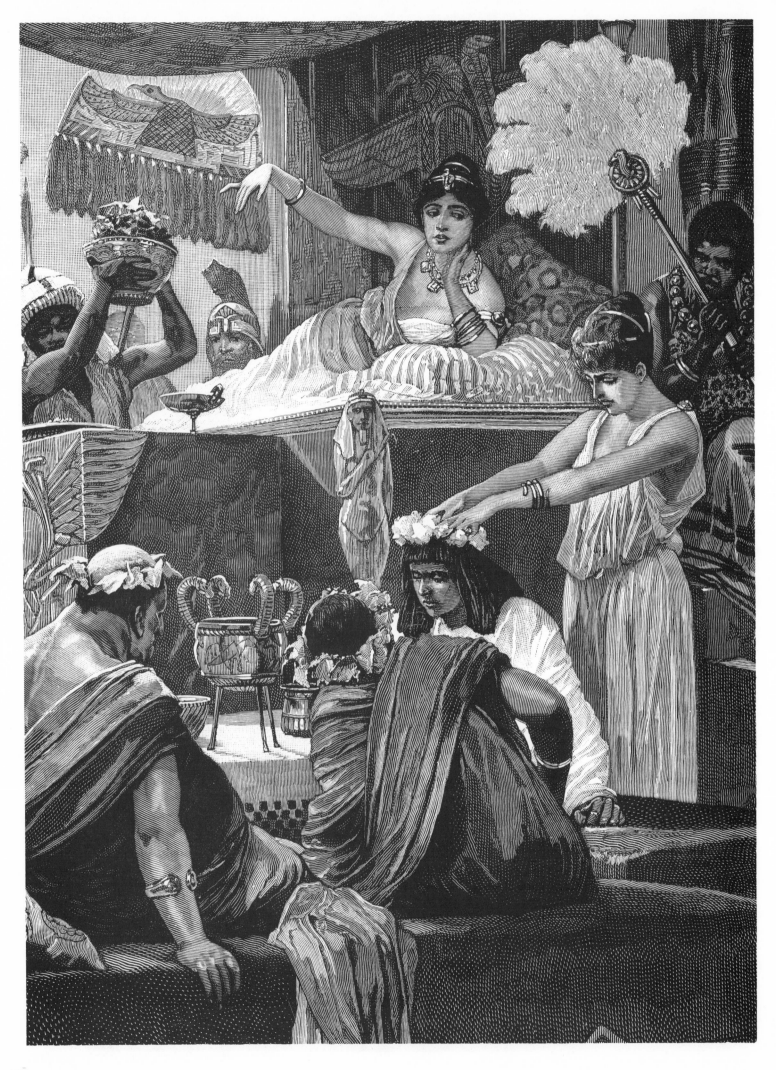

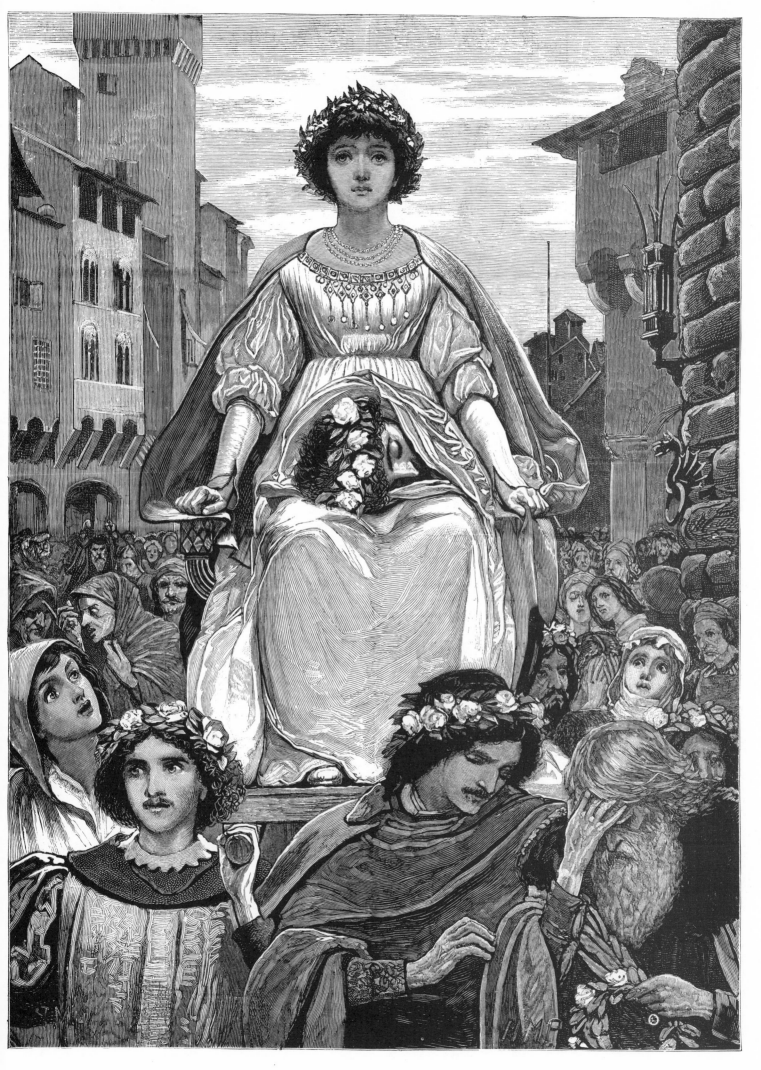

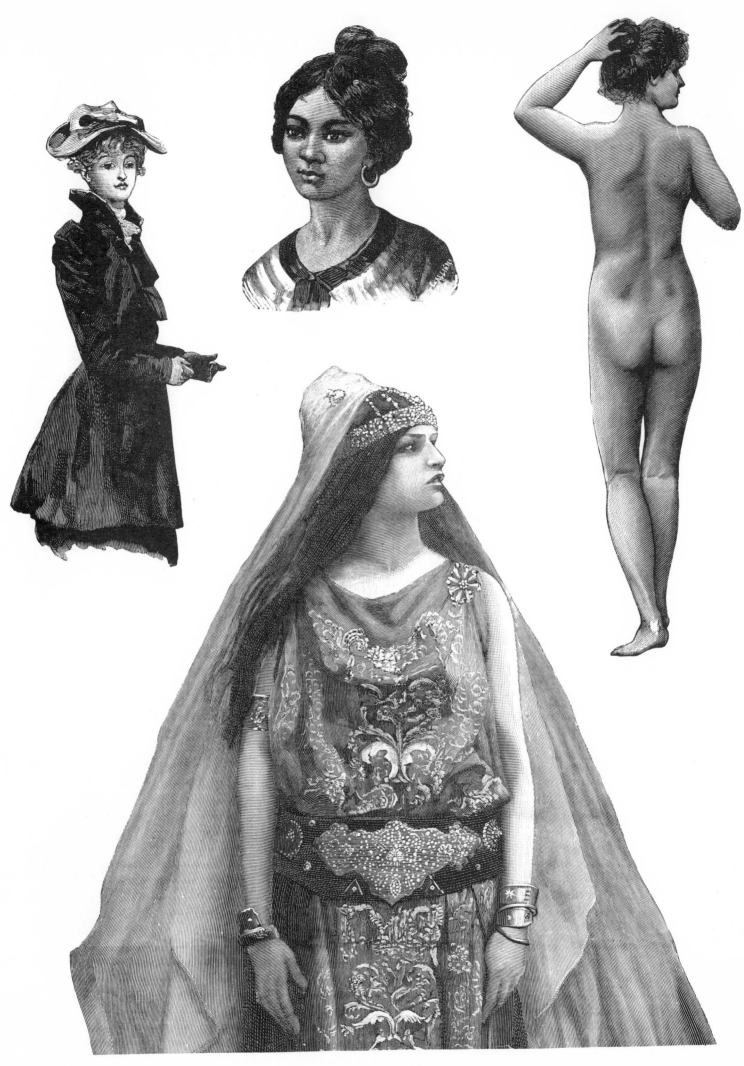

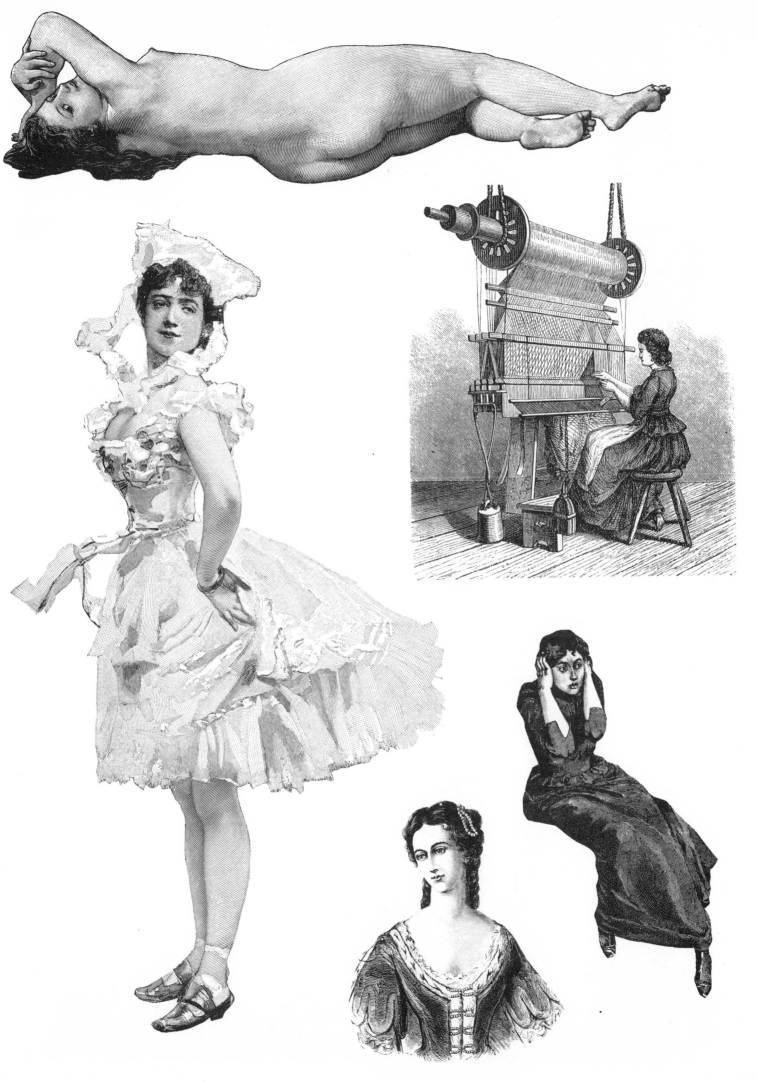

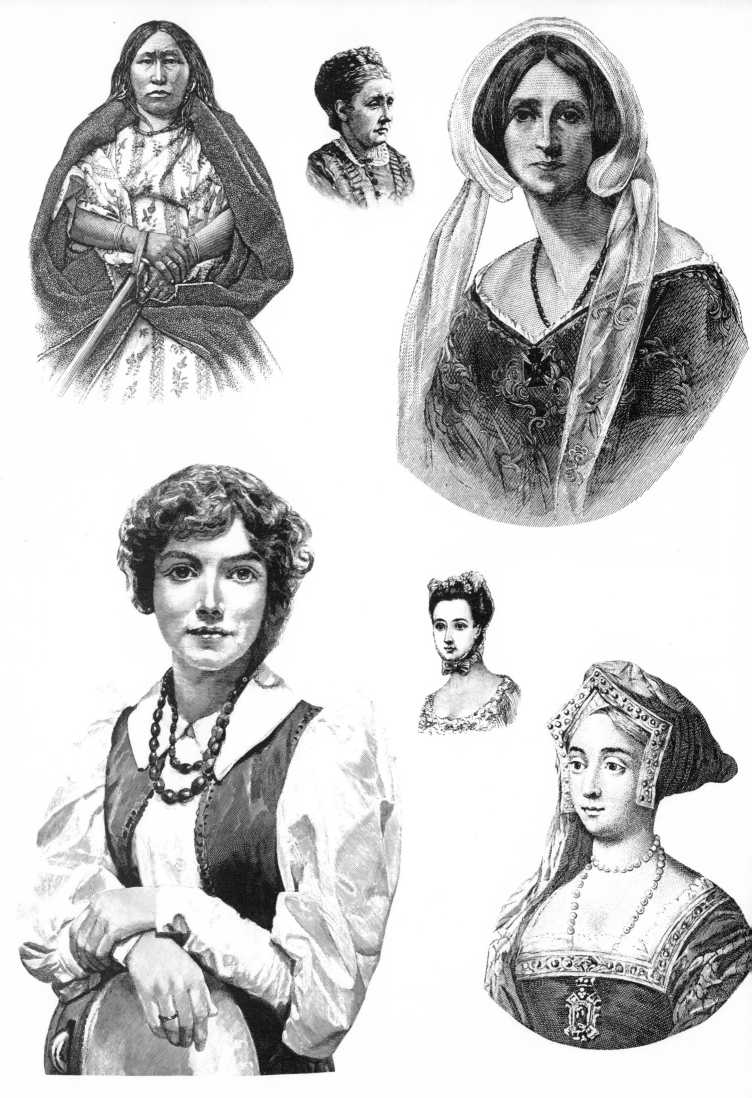

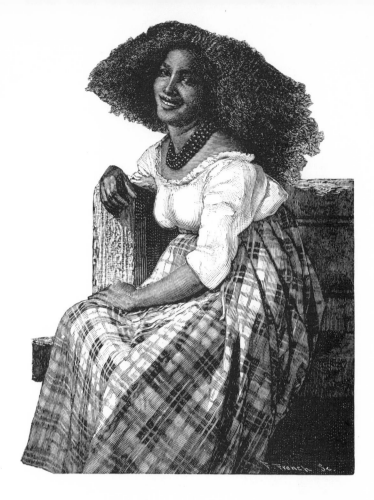

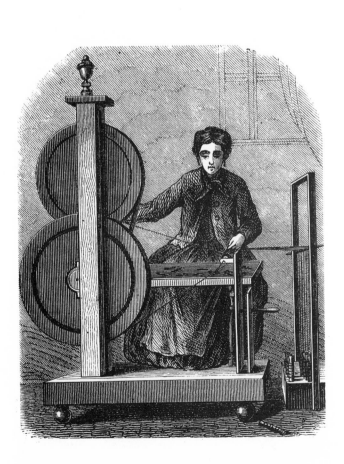

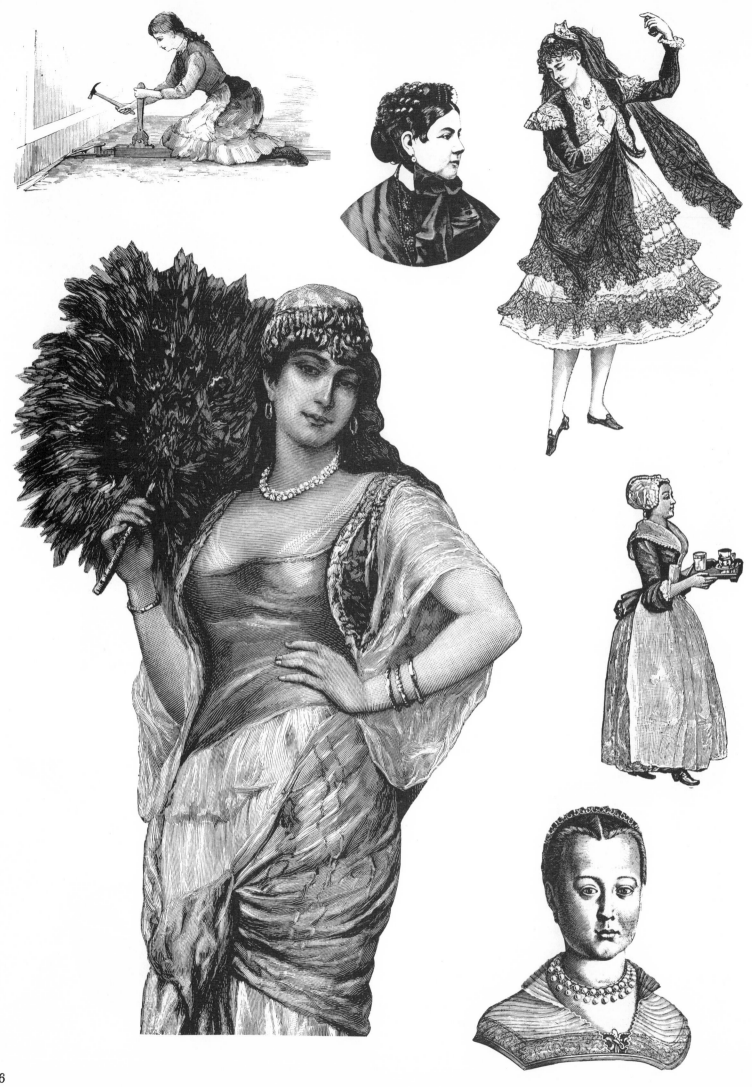

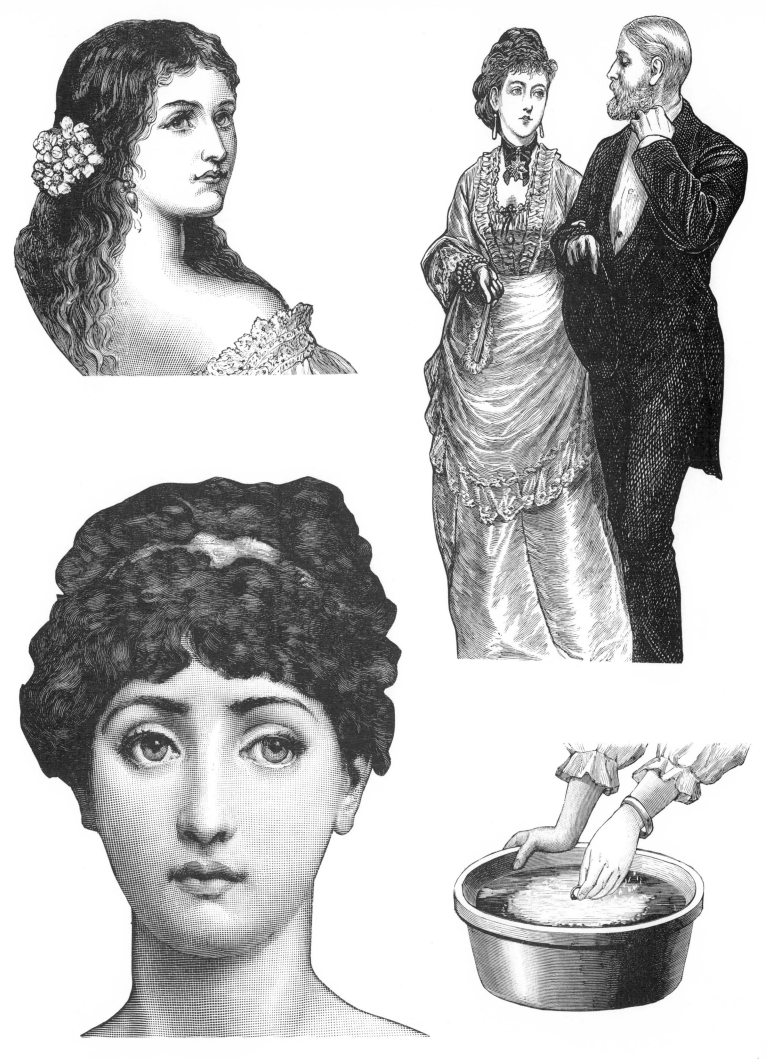

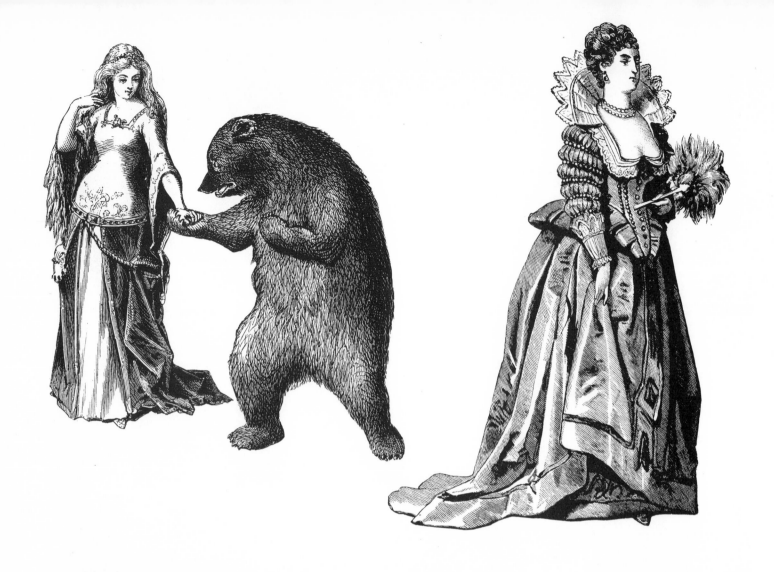

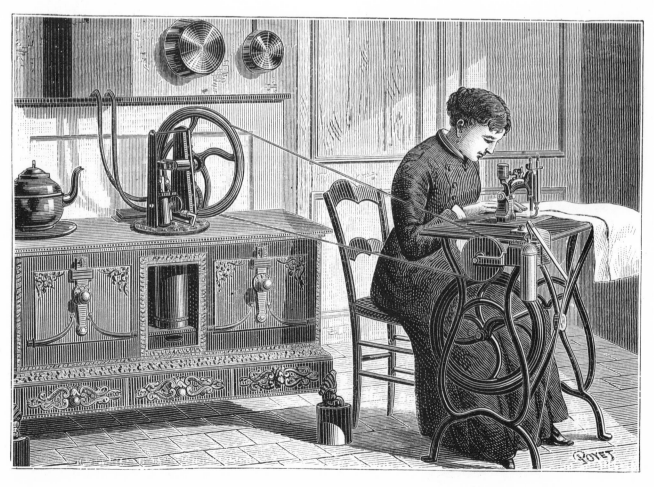

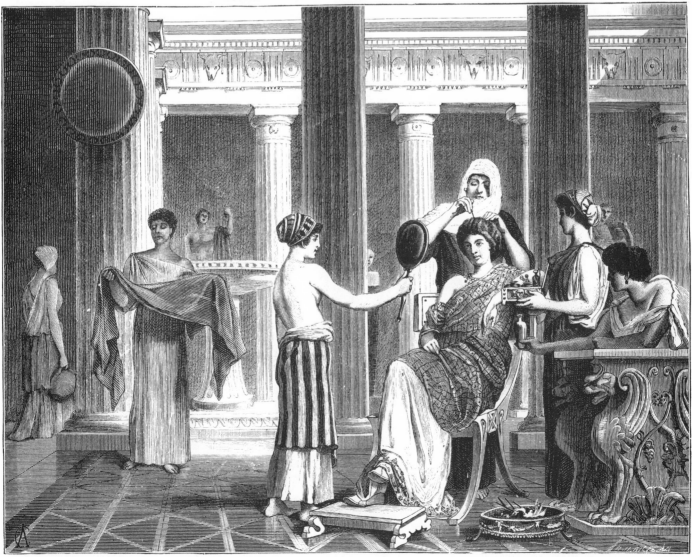

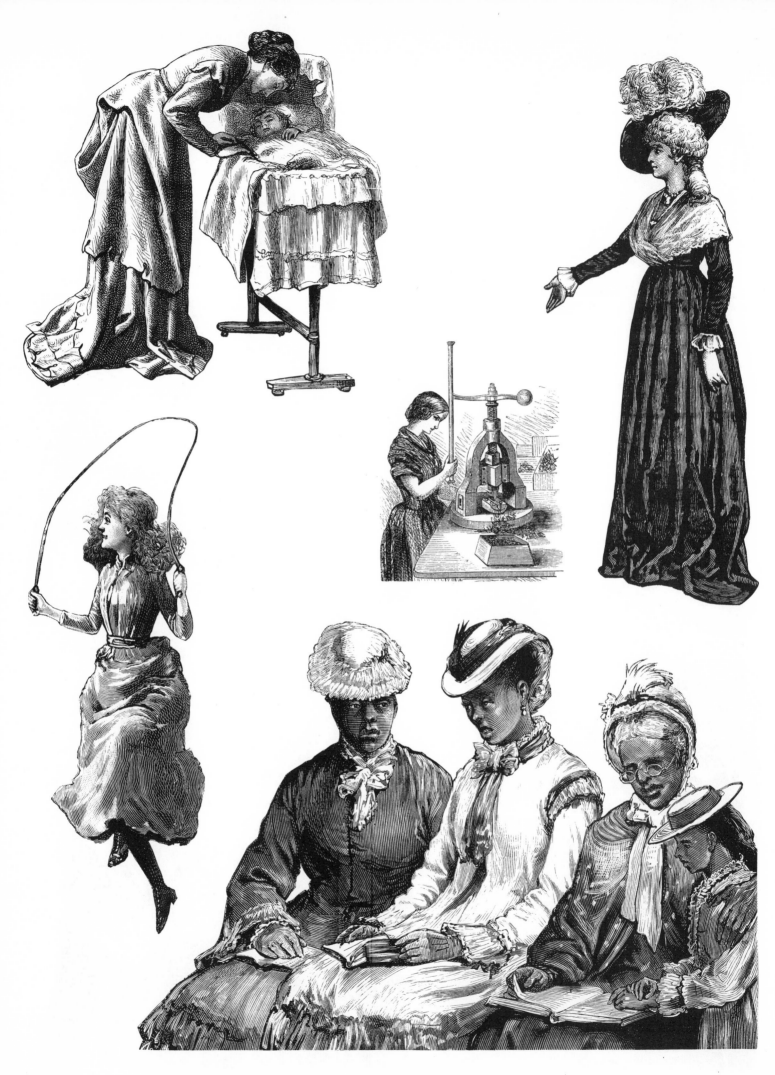

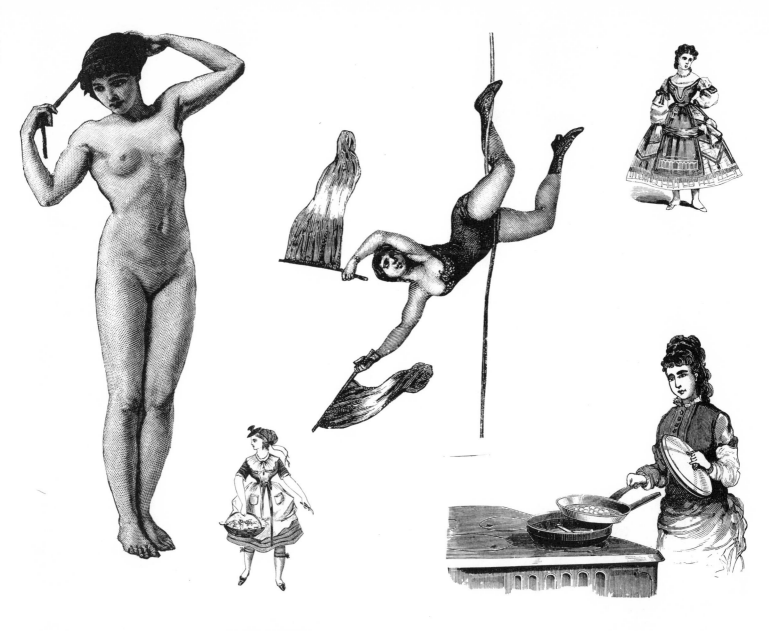

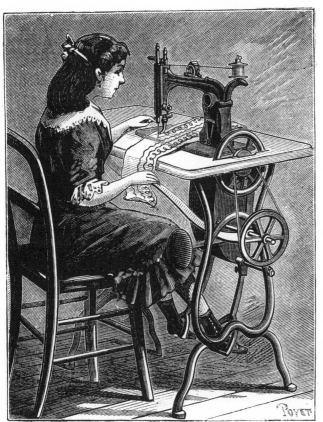

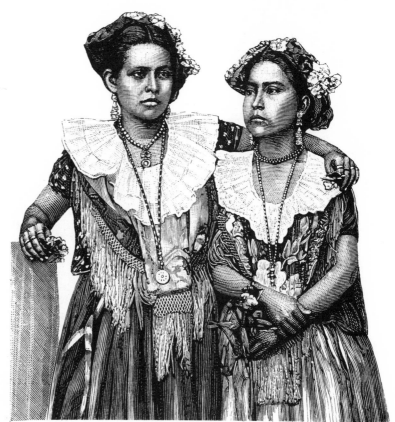

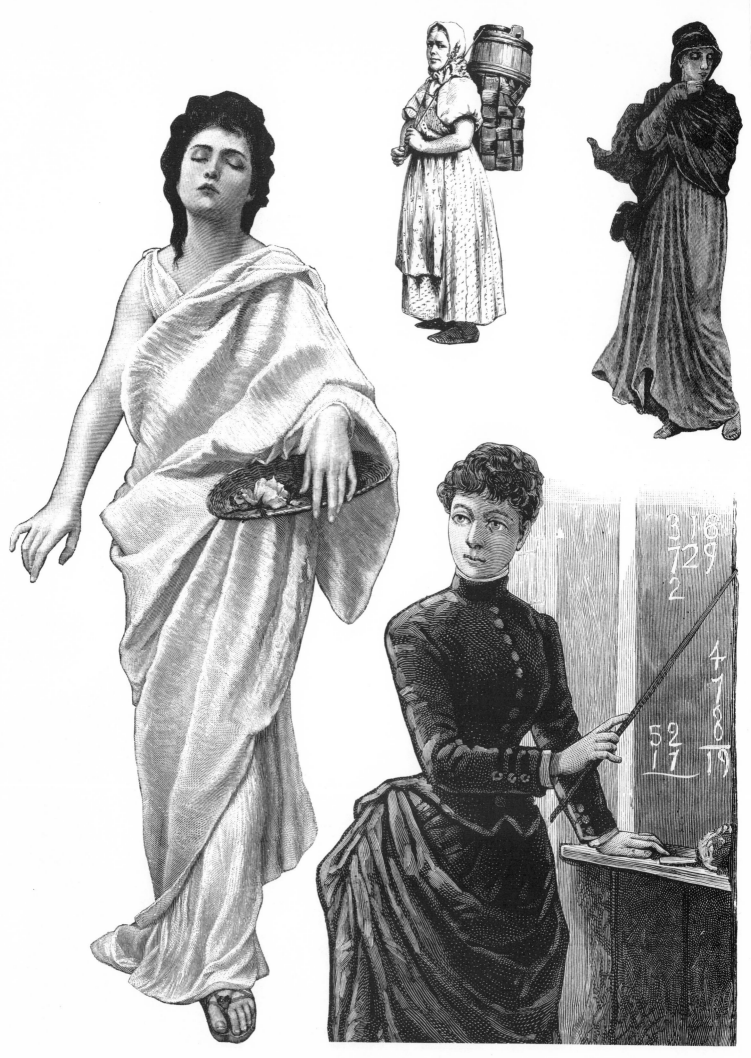

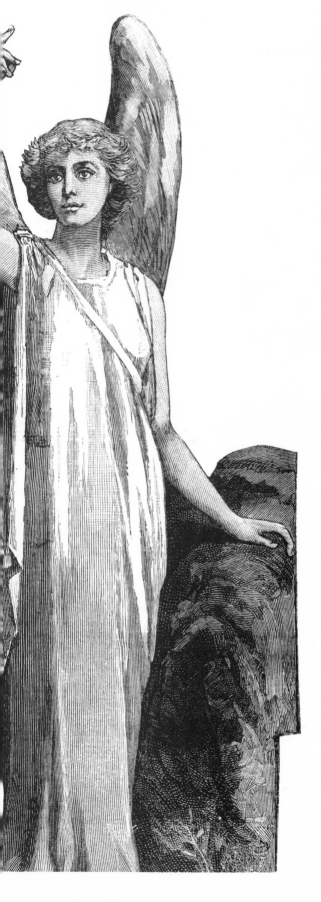

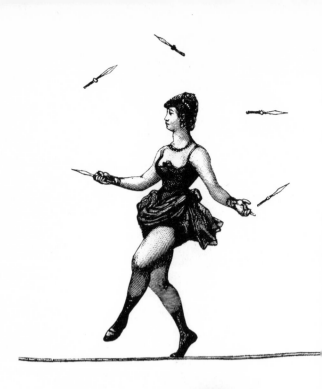

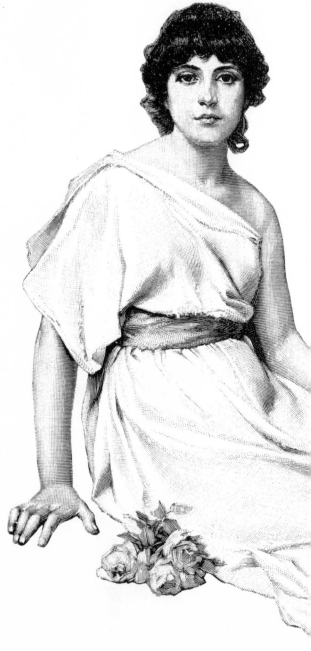

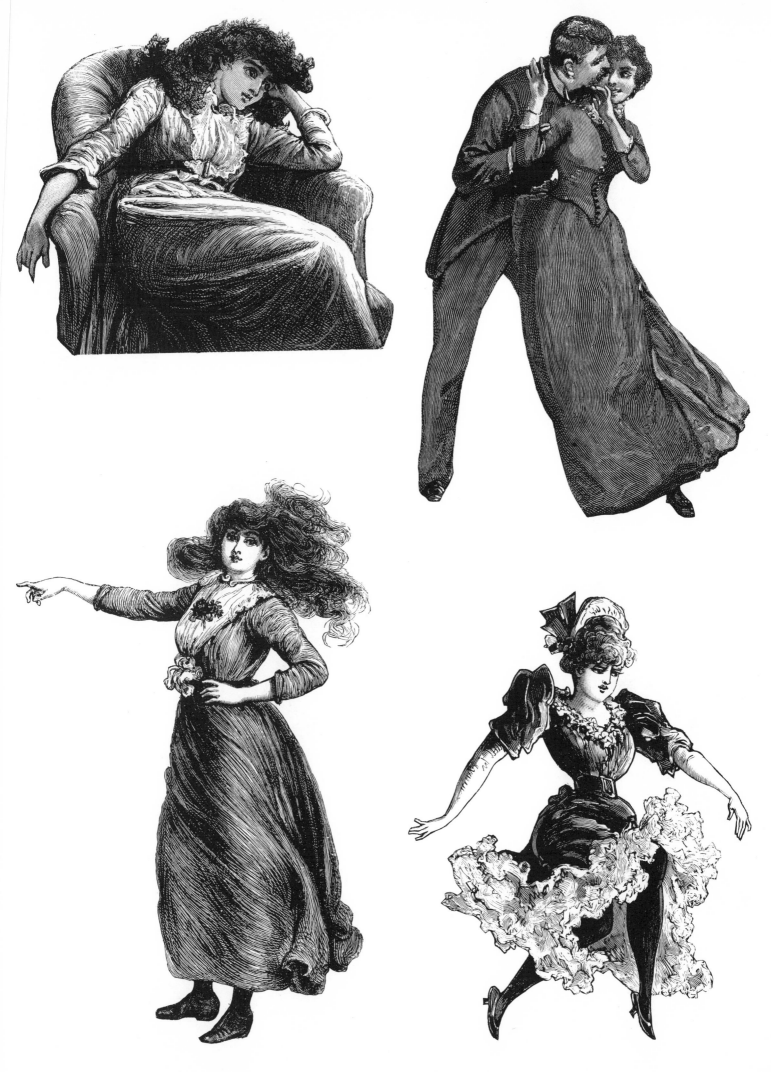

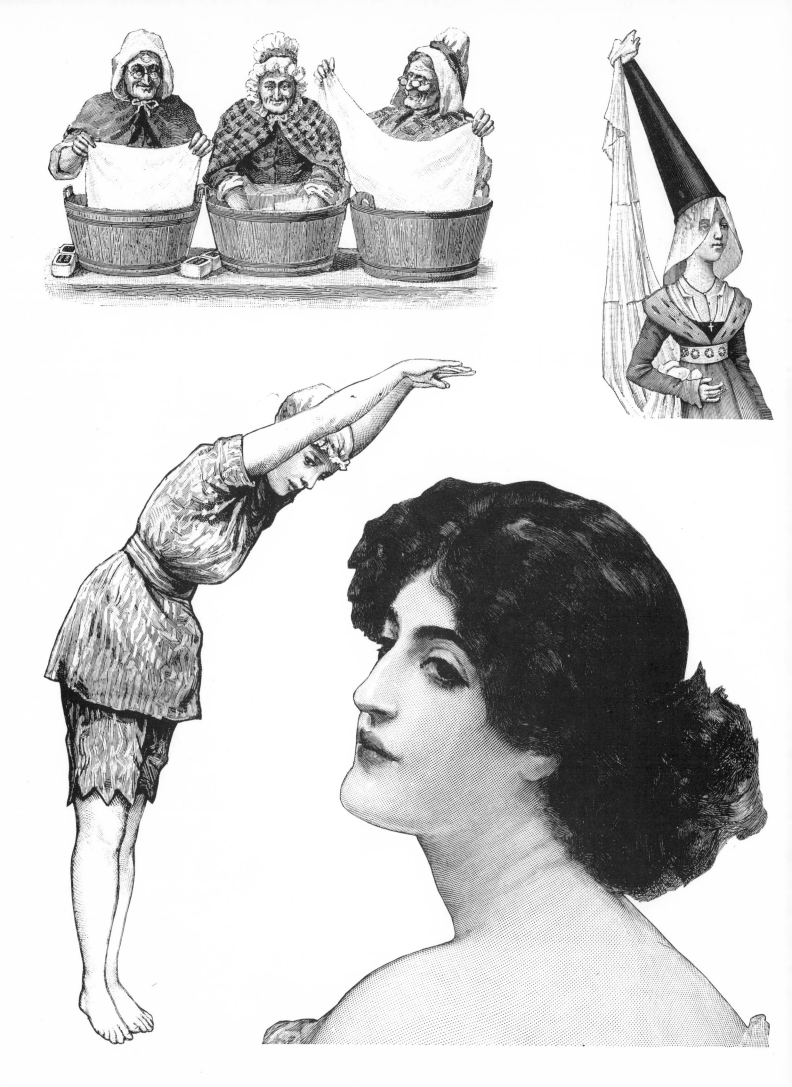

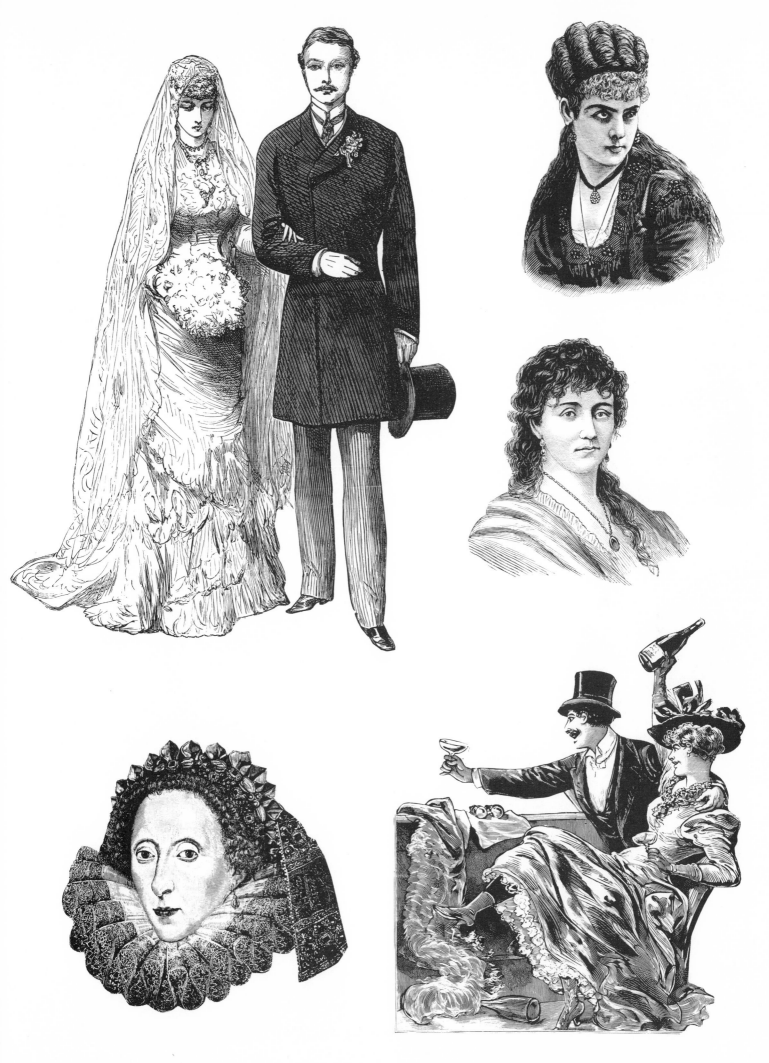

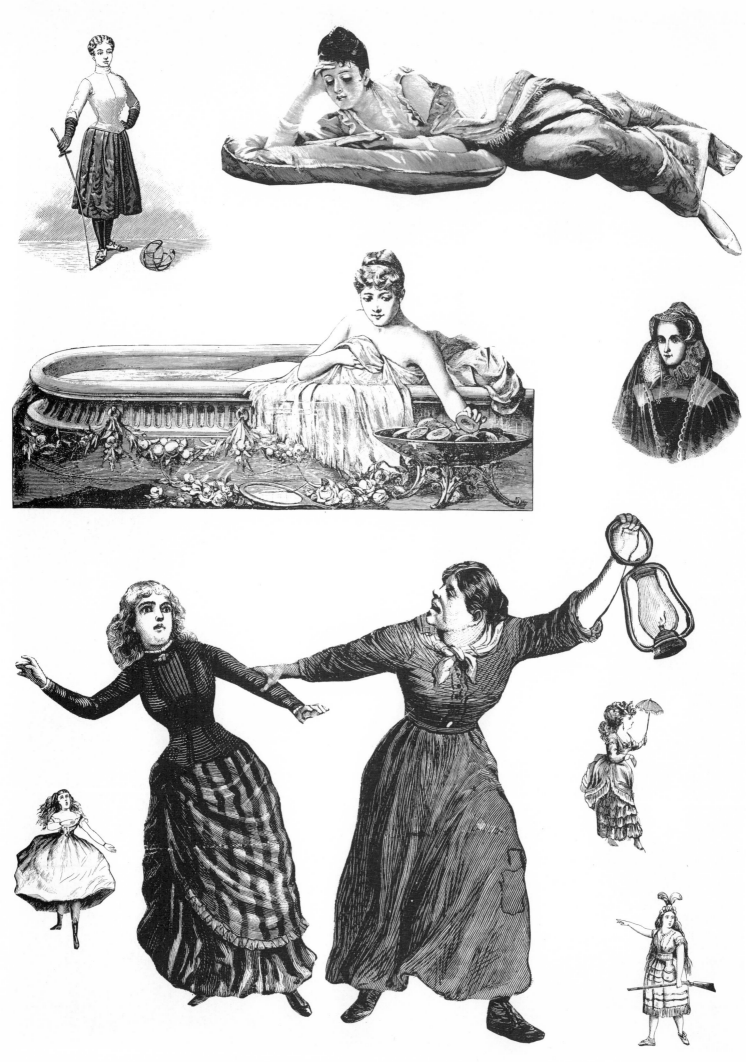

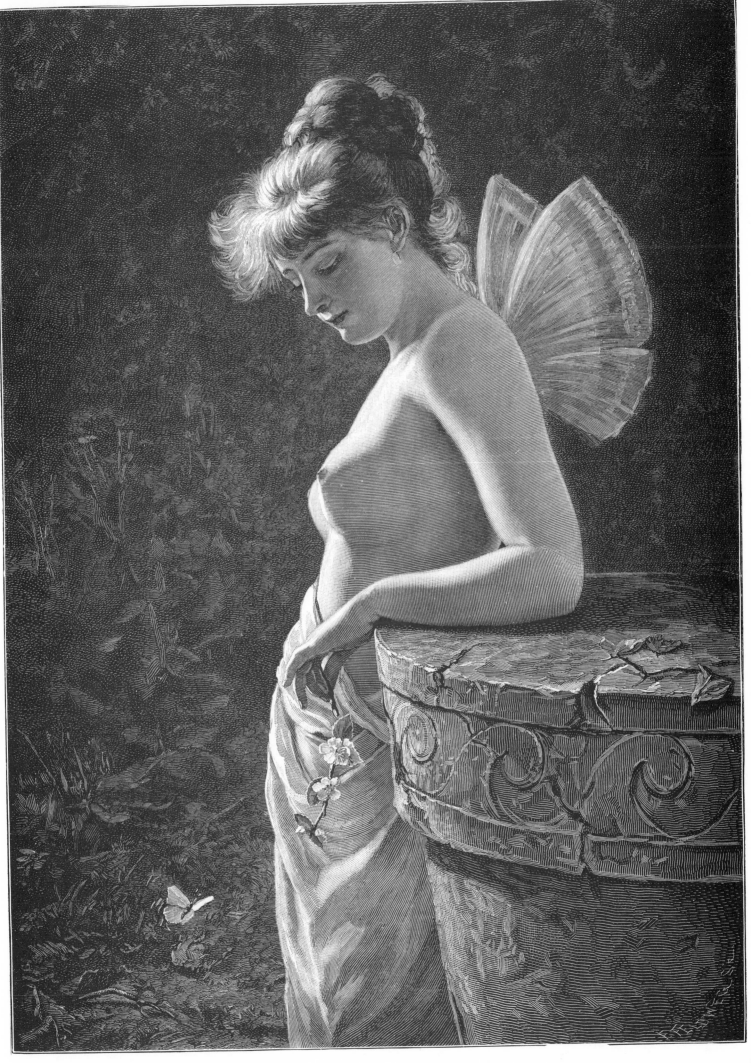

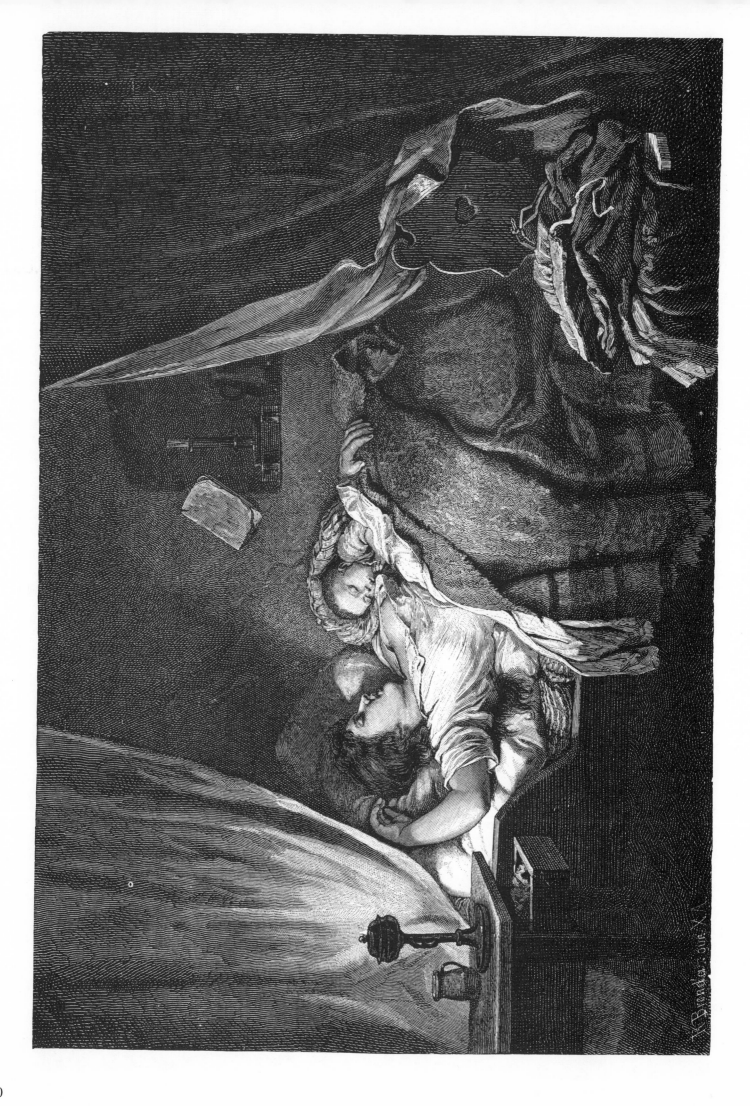

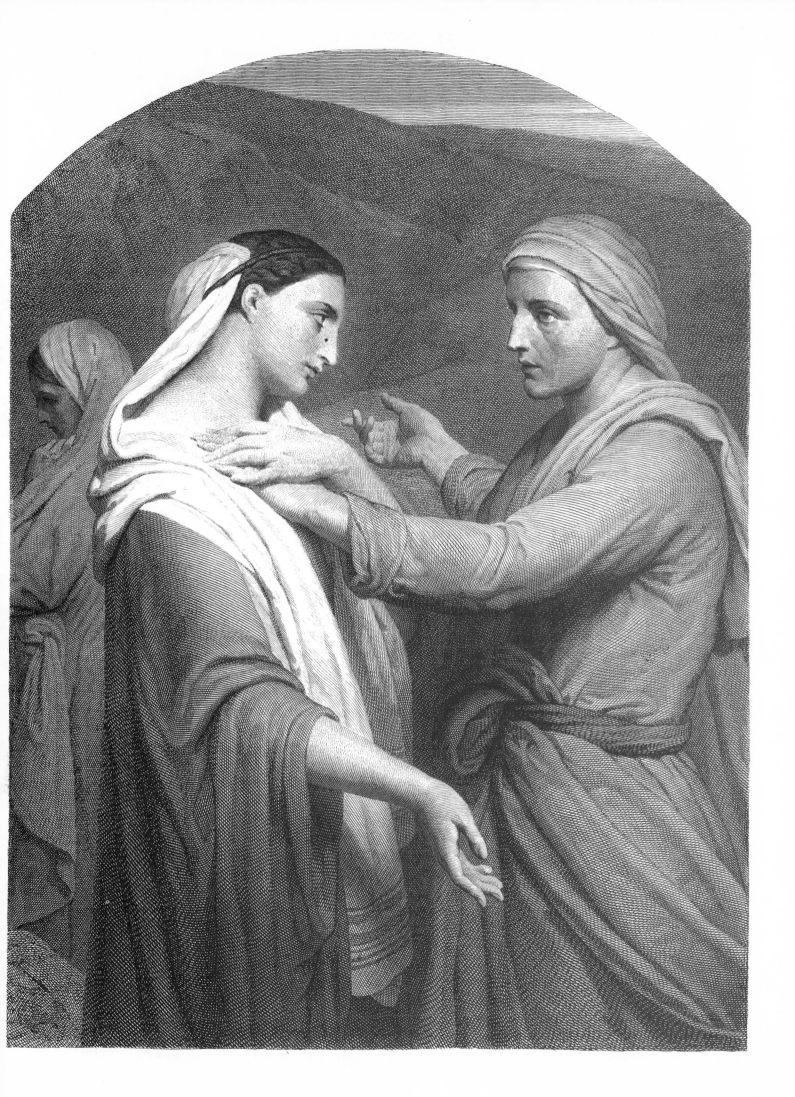

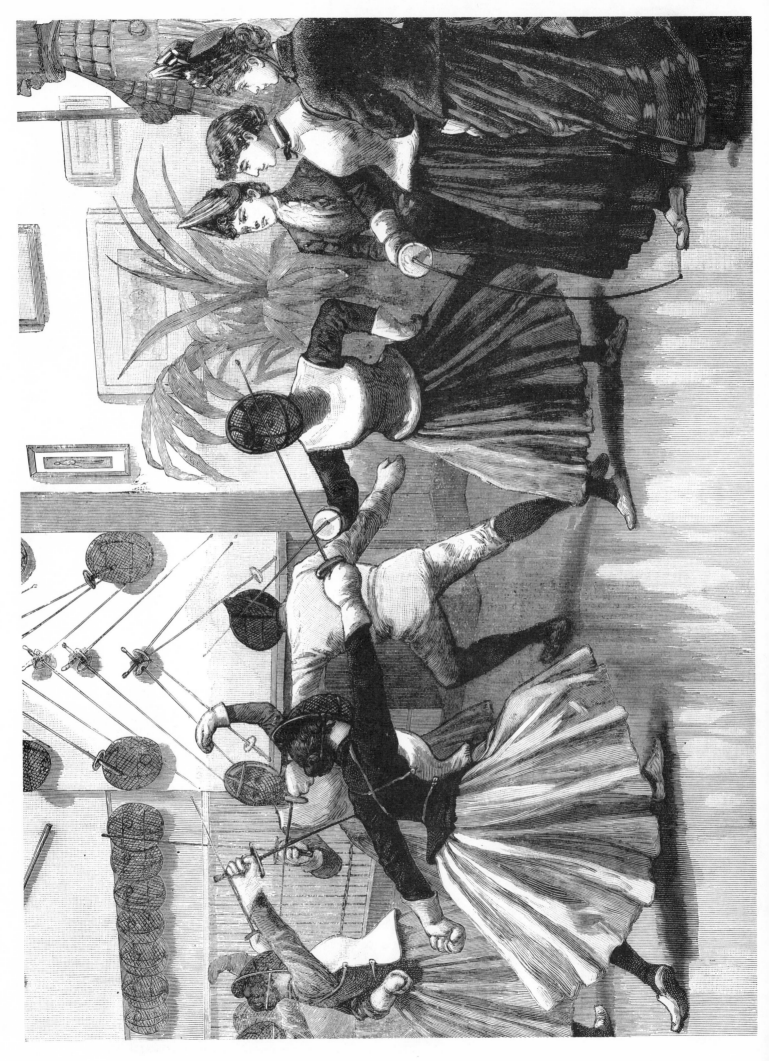

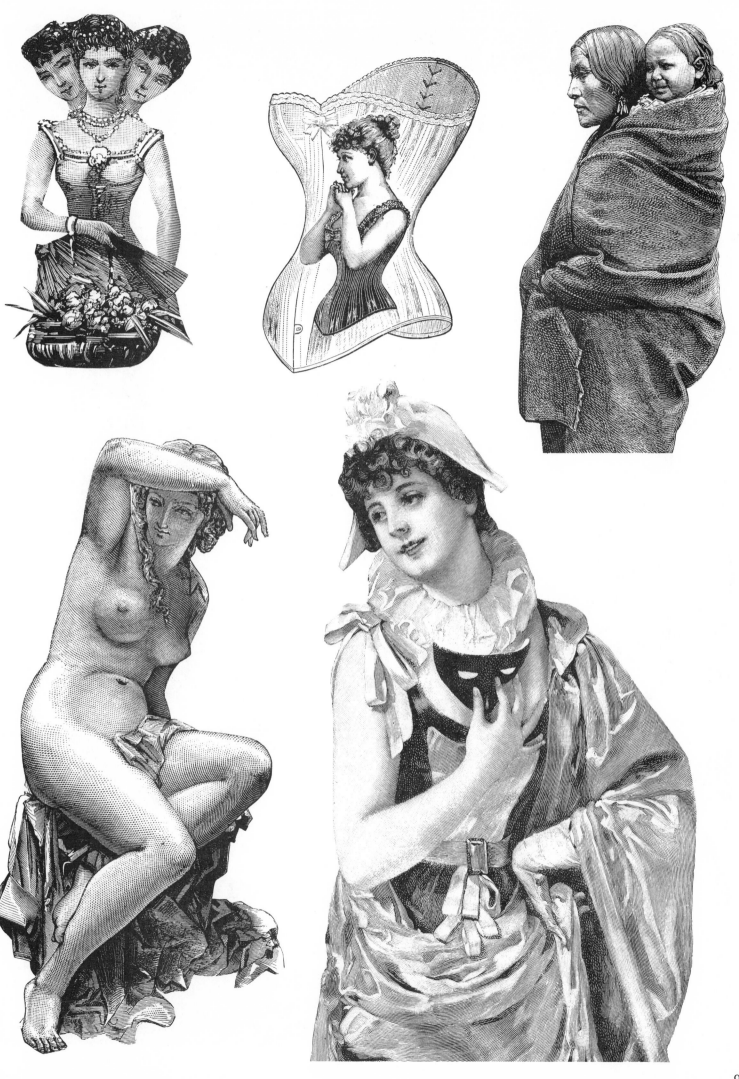

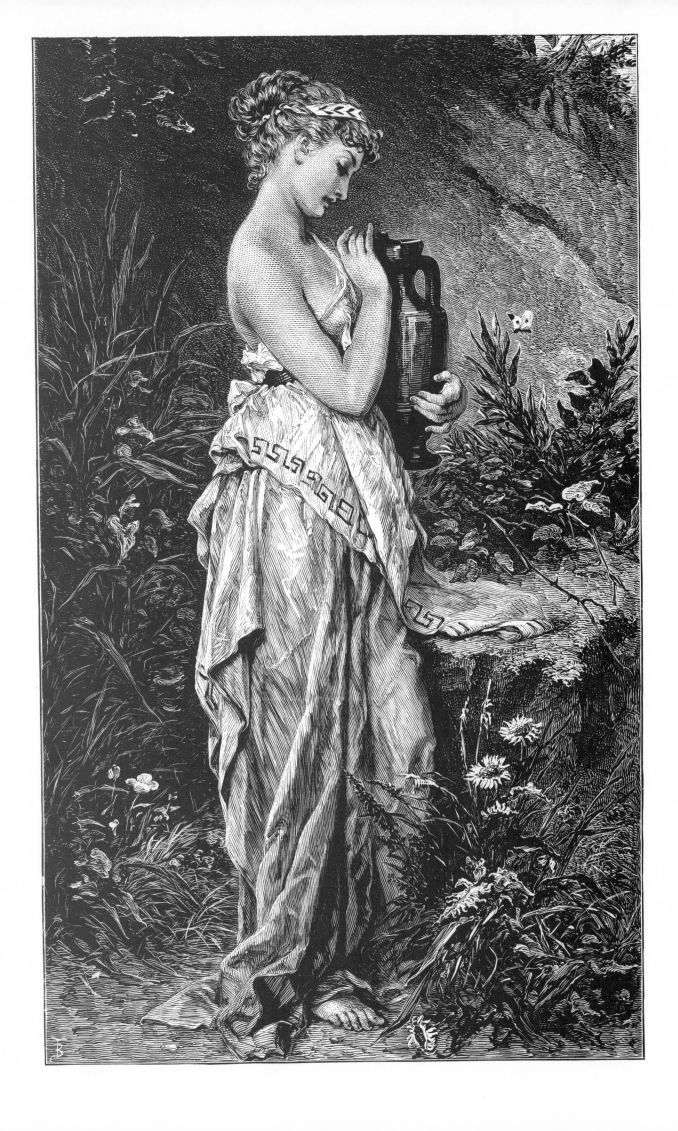

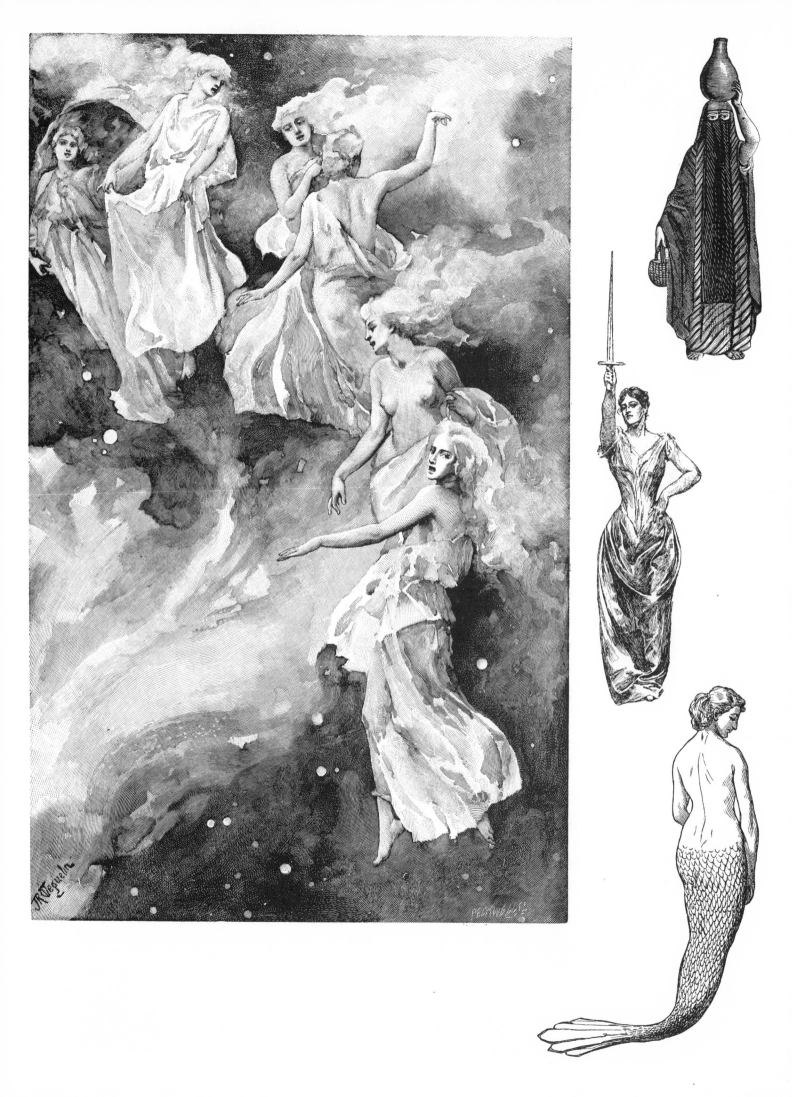

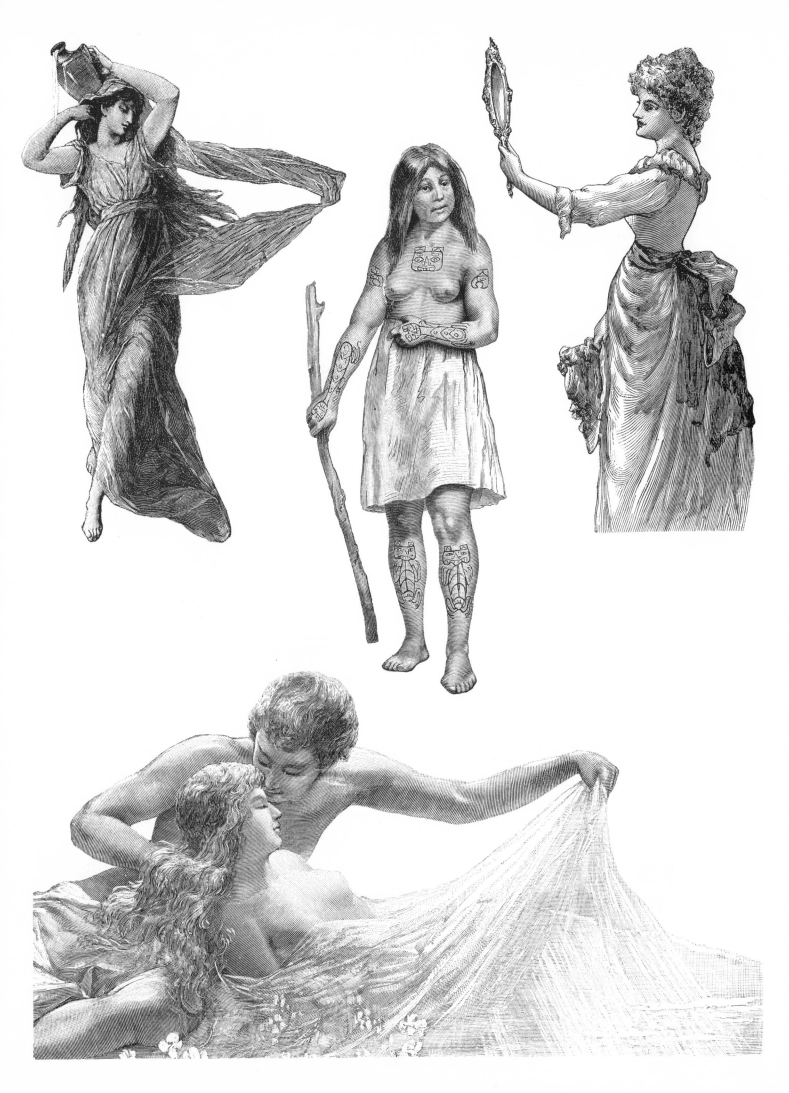

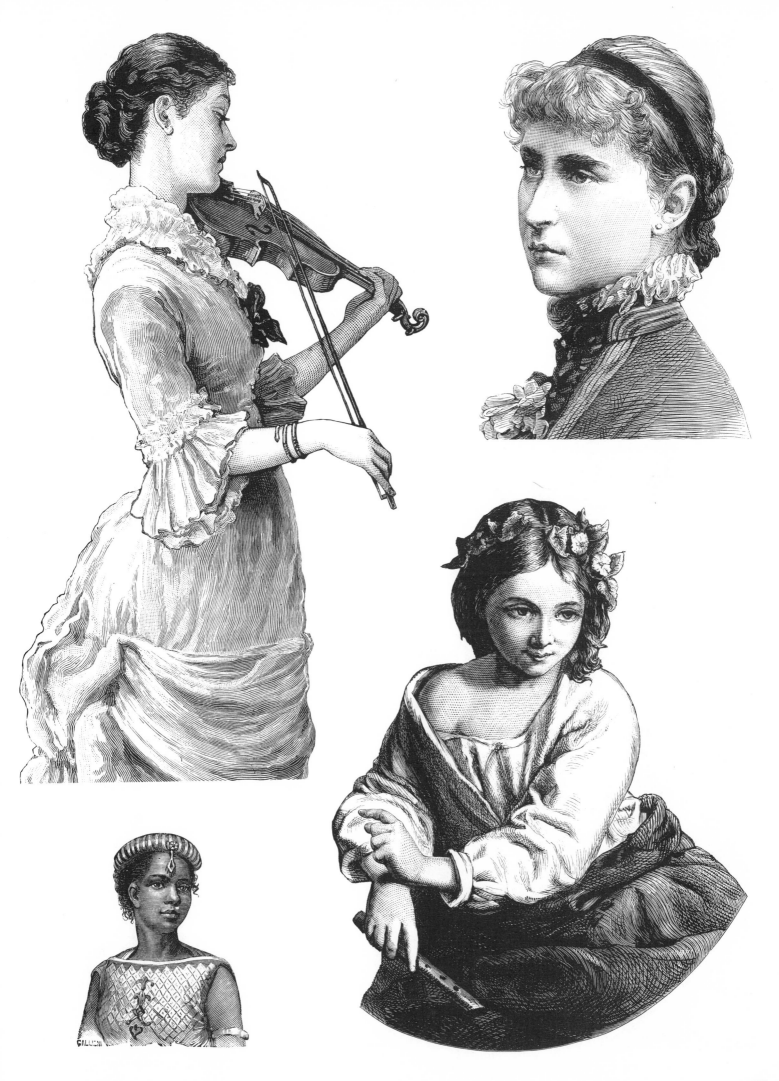

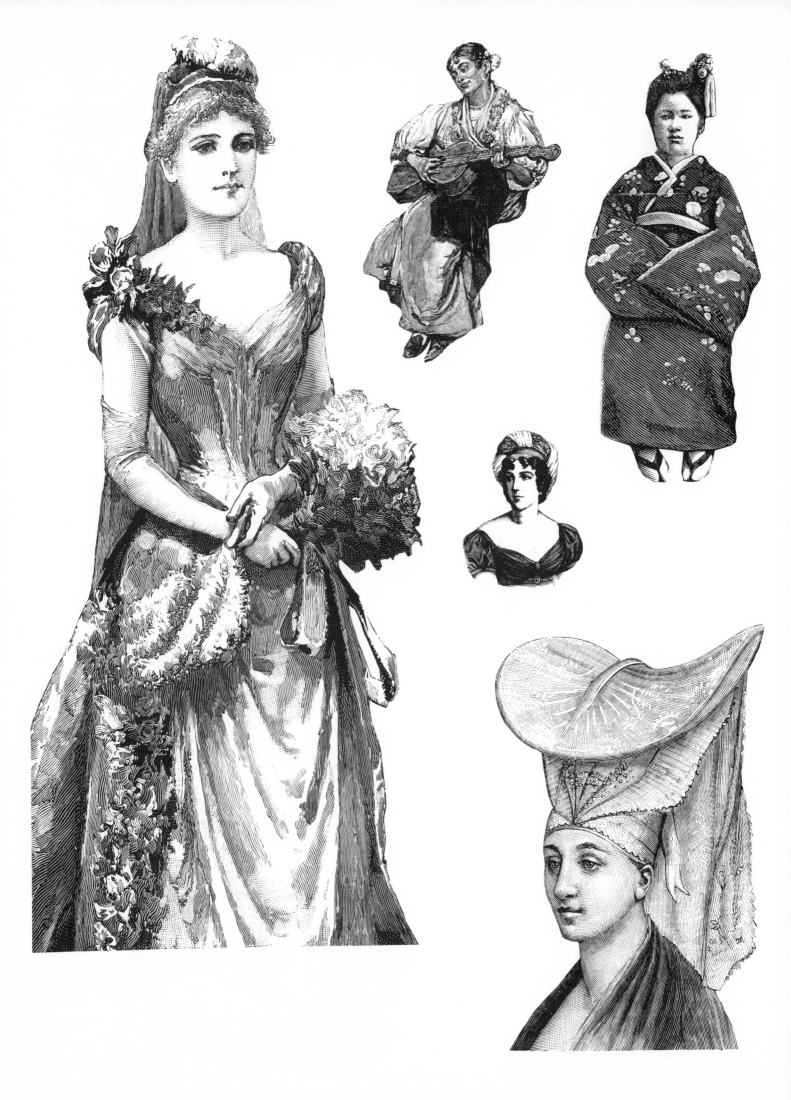

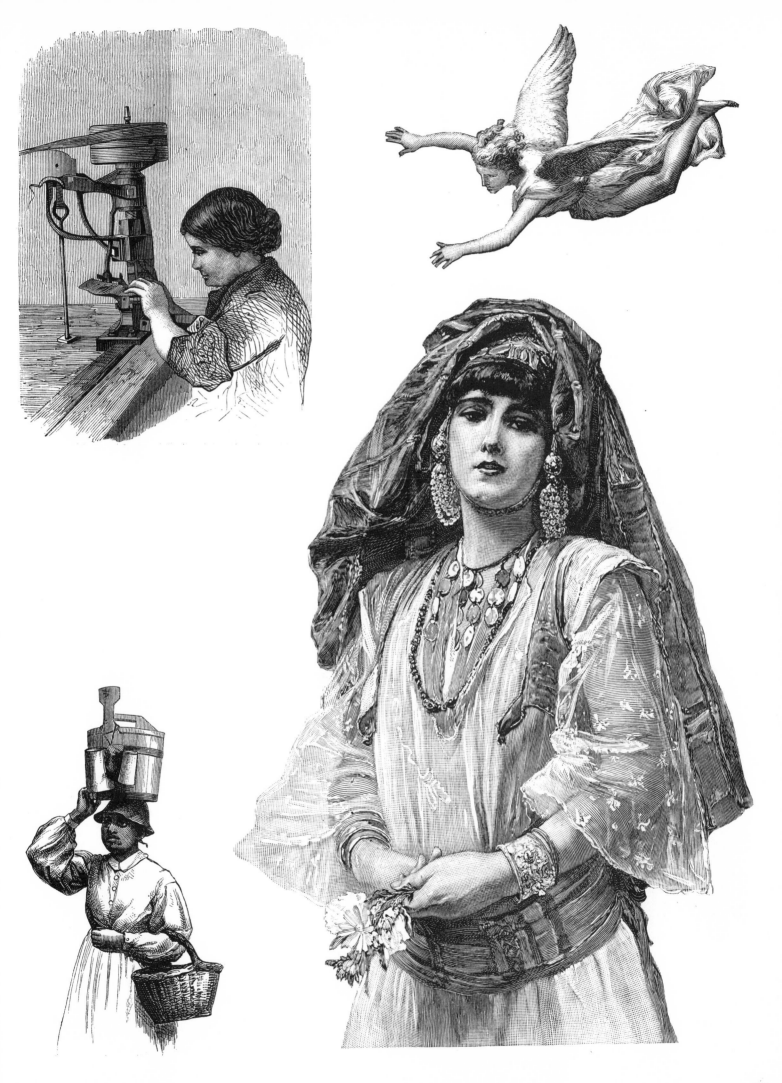

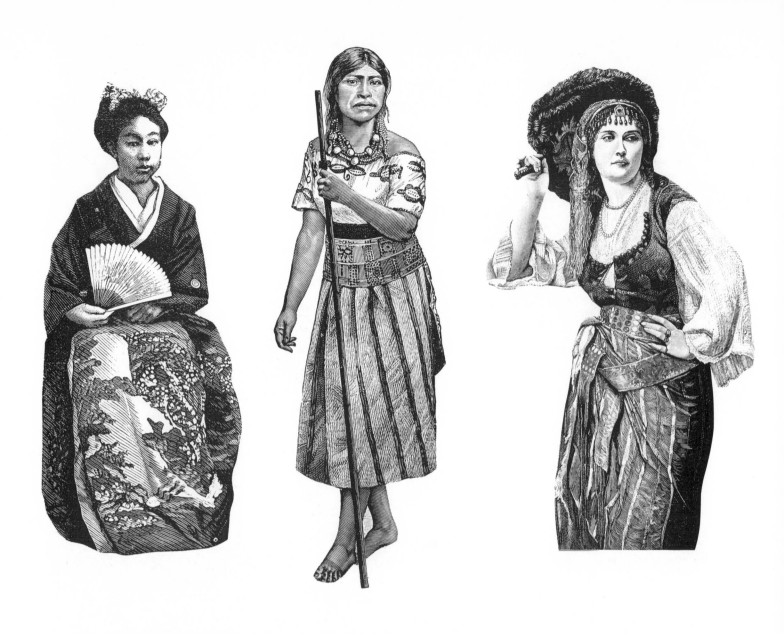

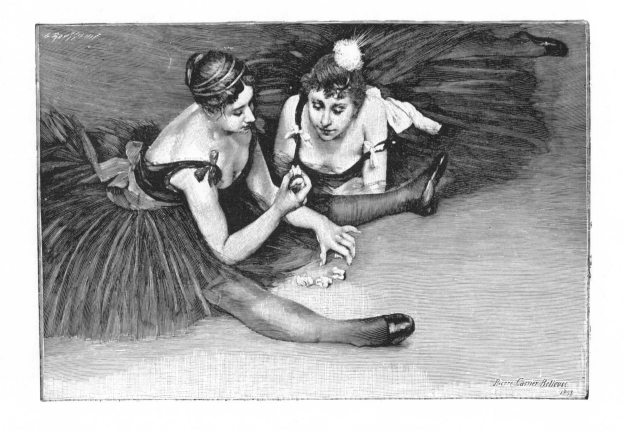

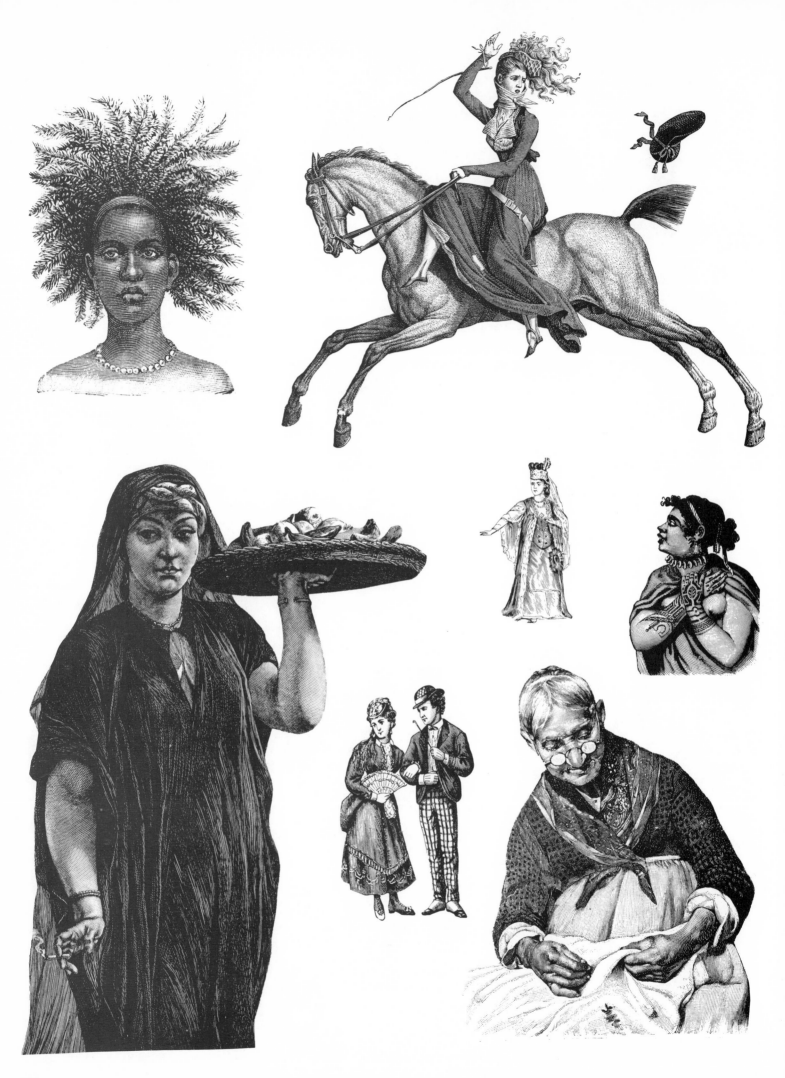

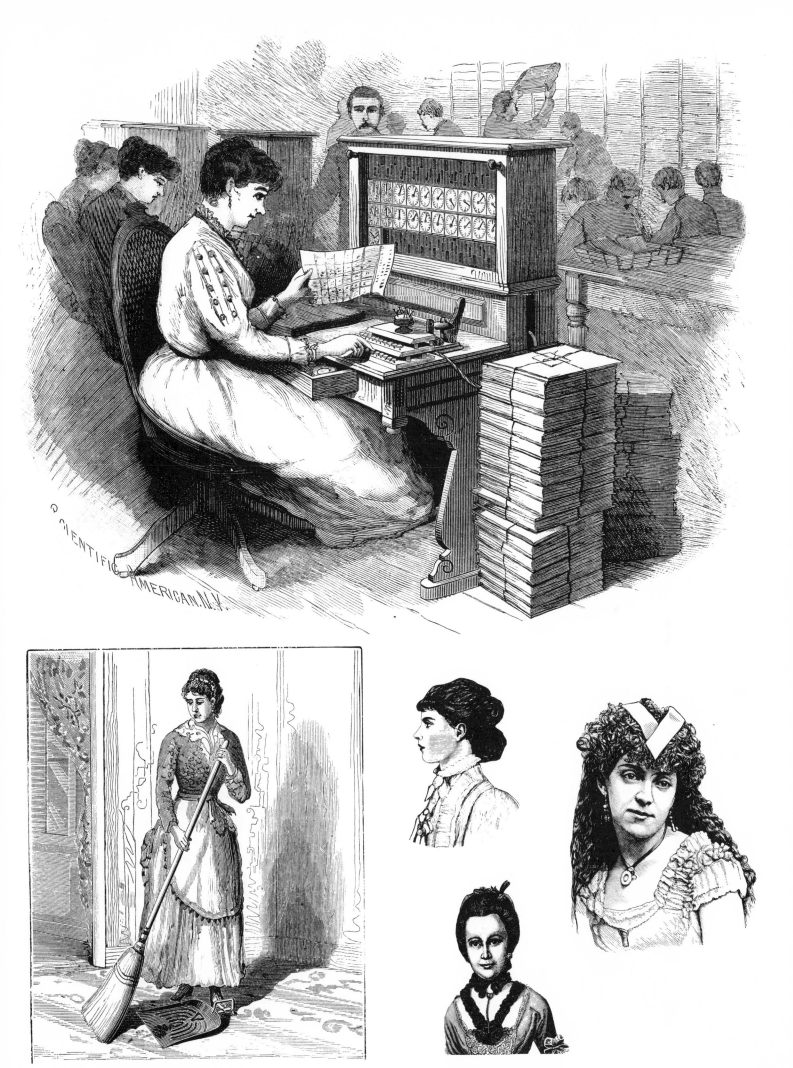

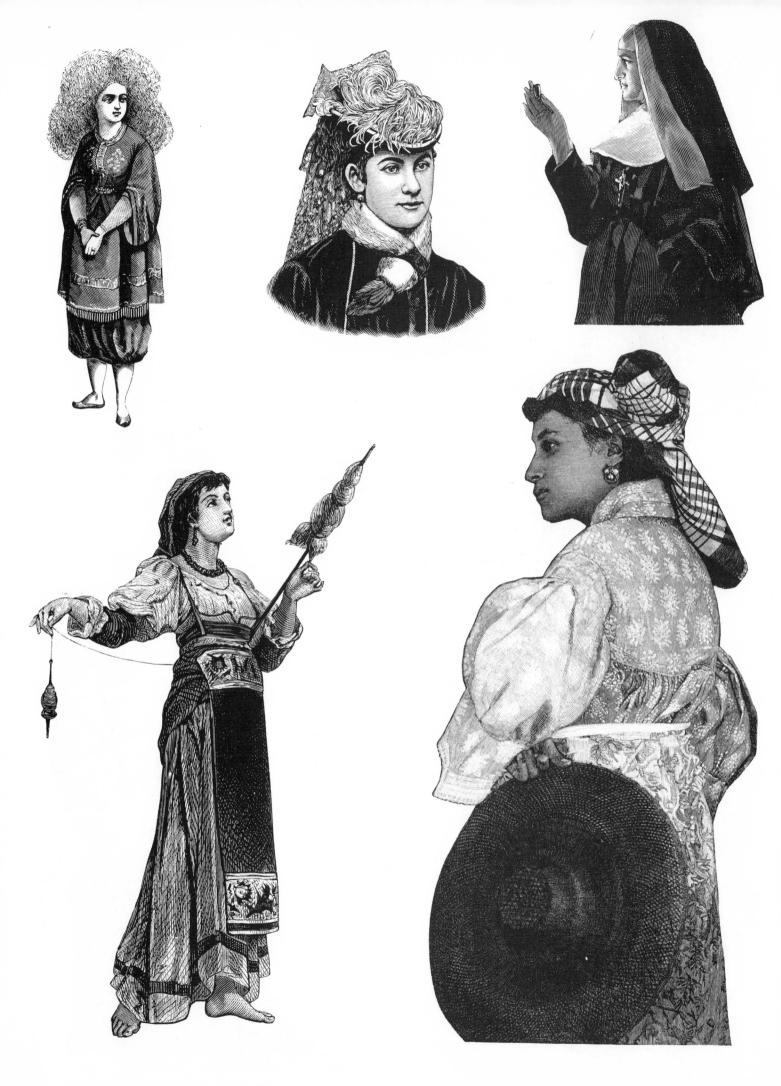

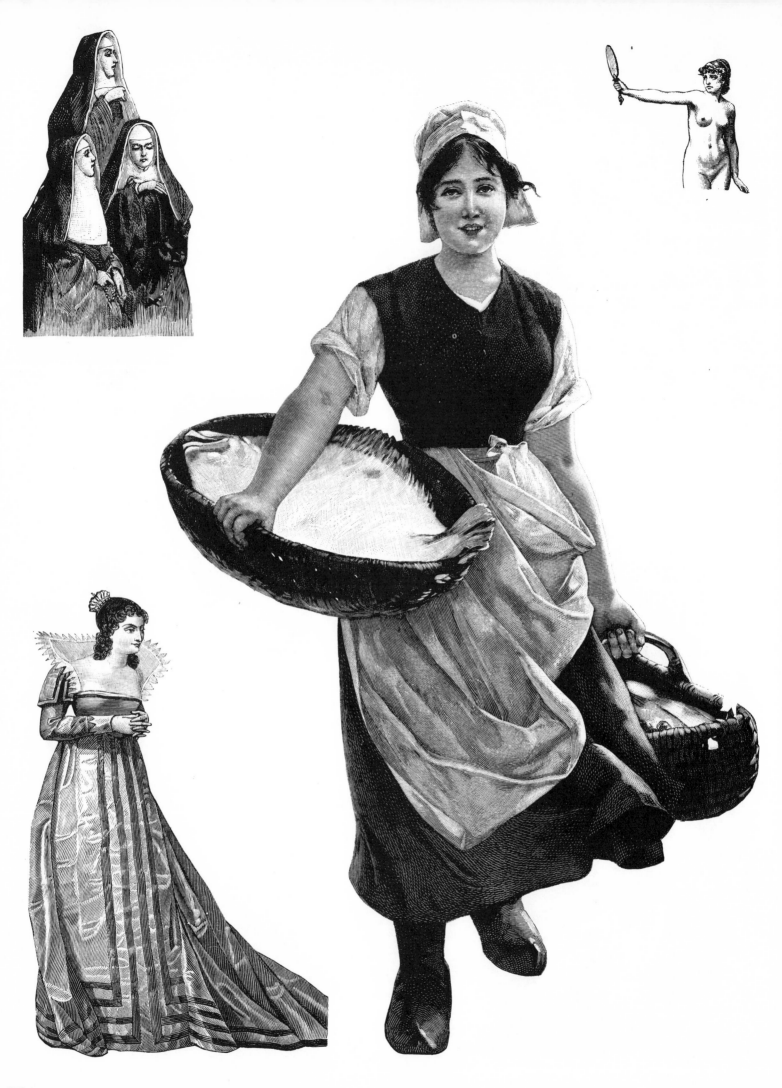

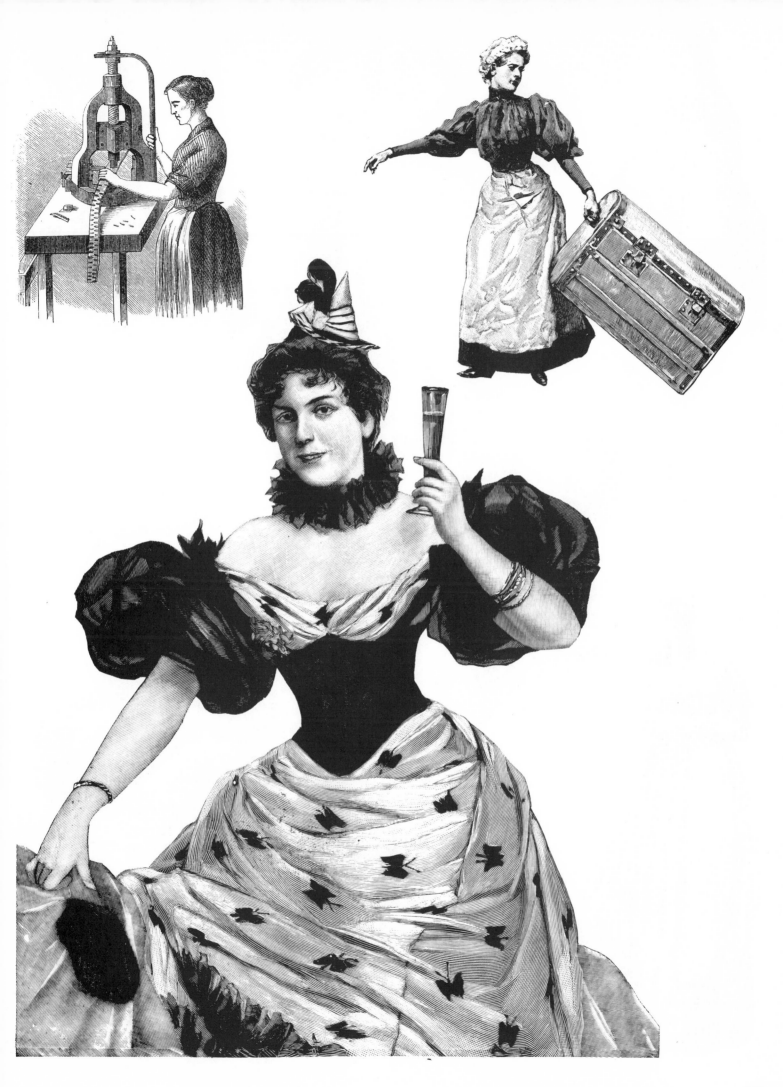

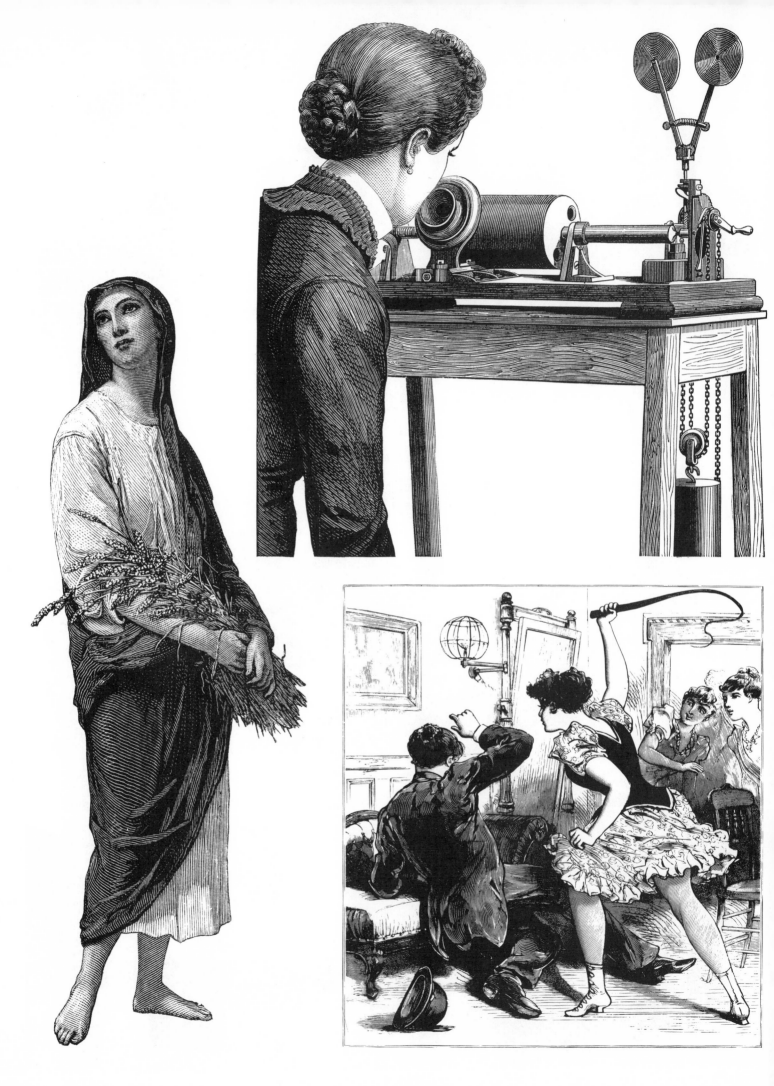

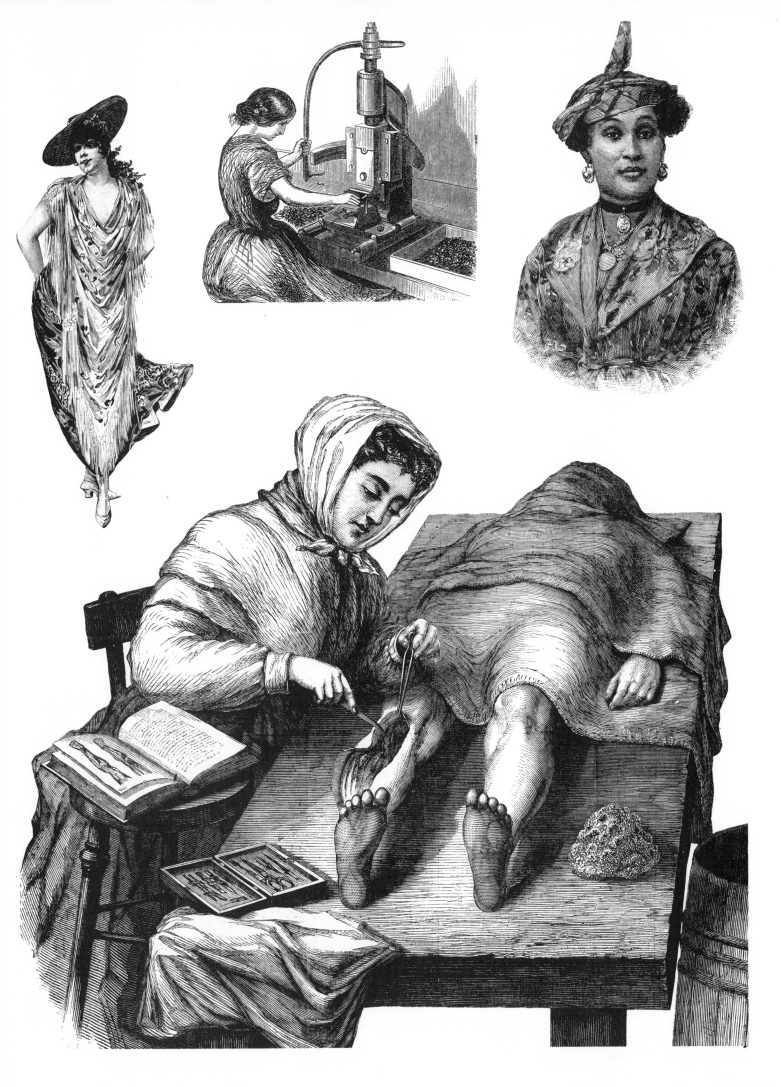

114

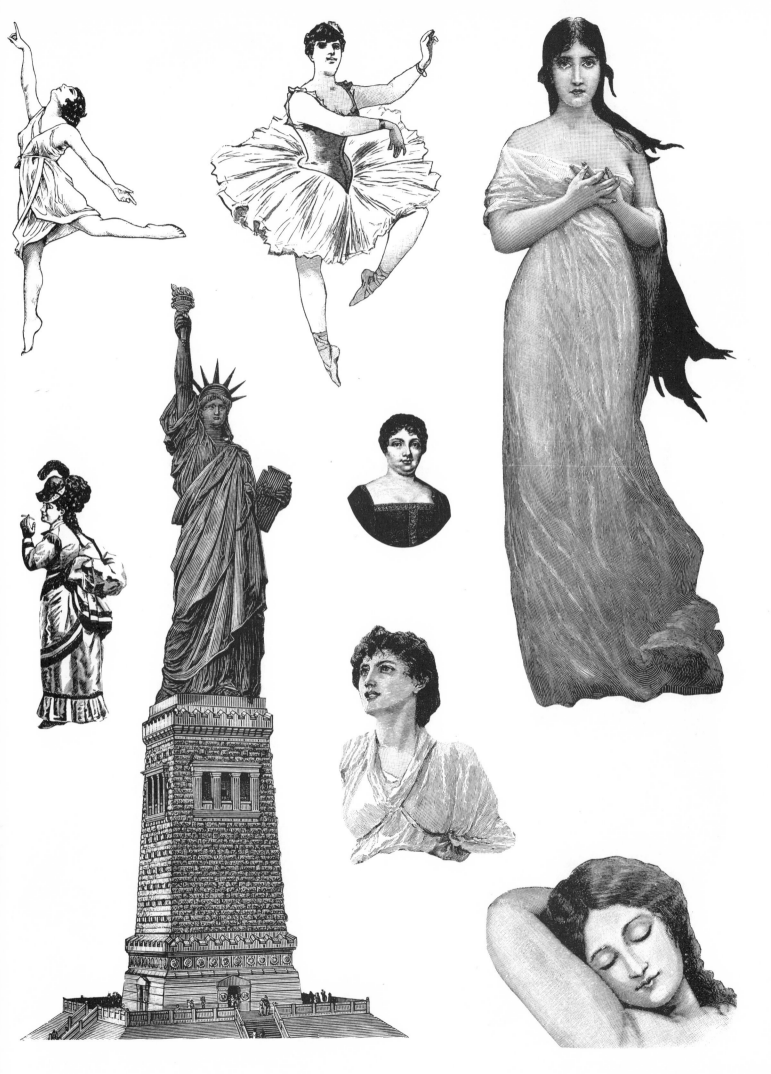

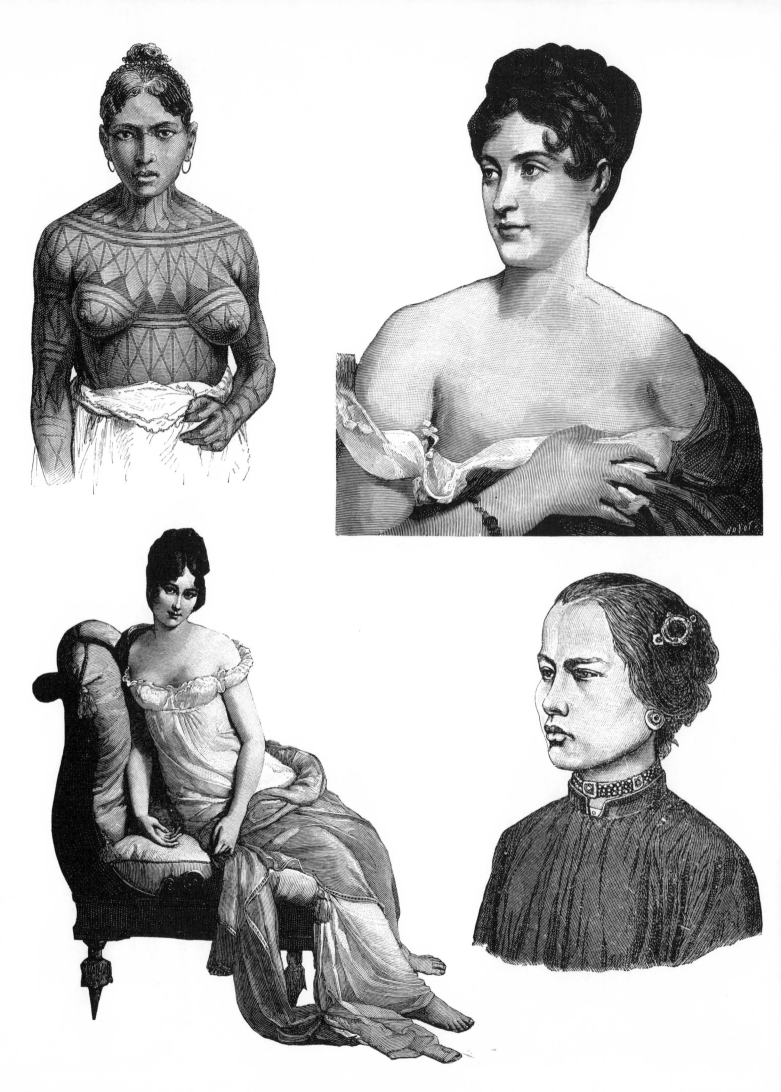

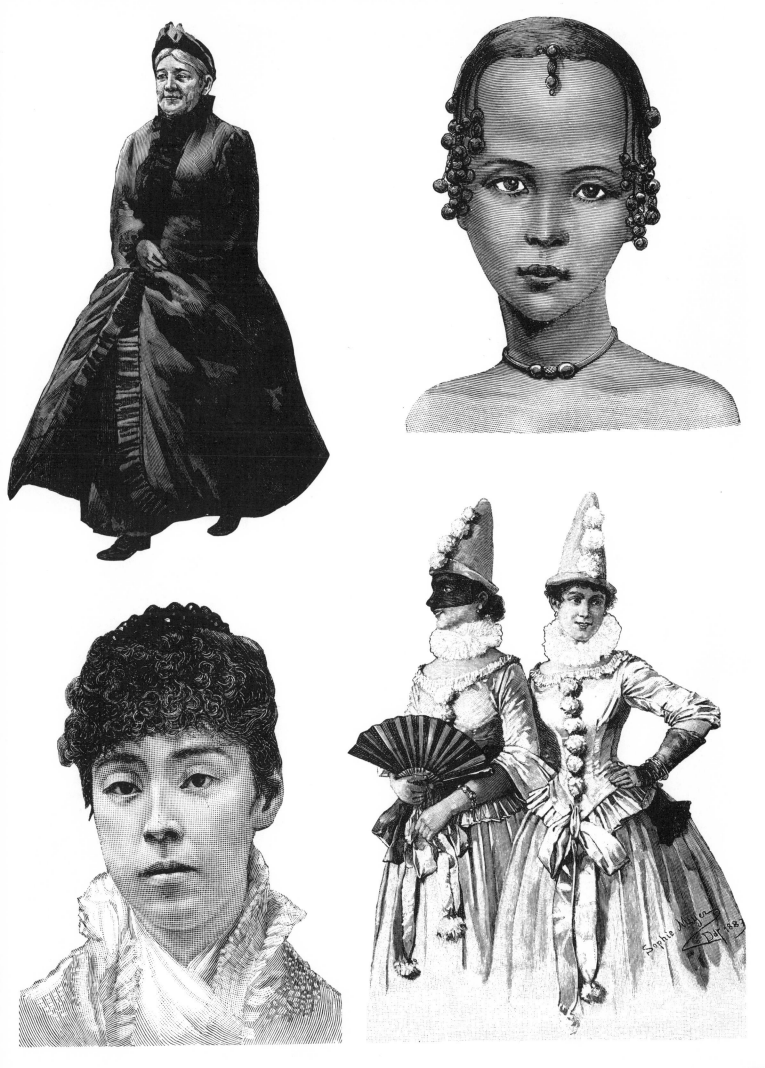

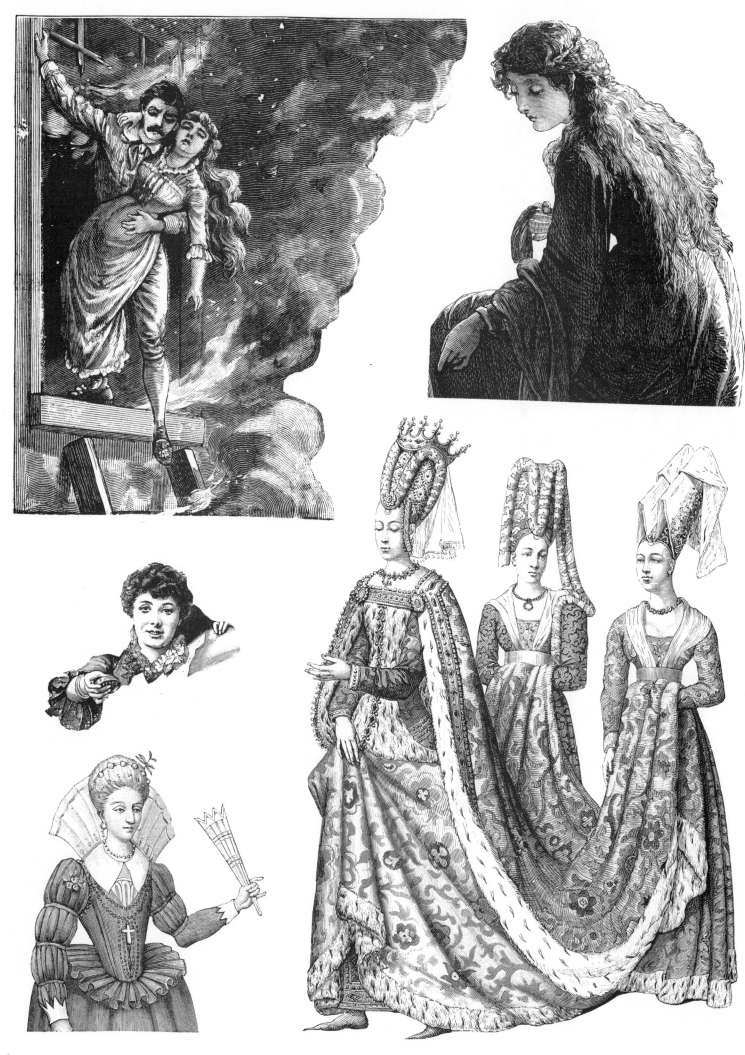

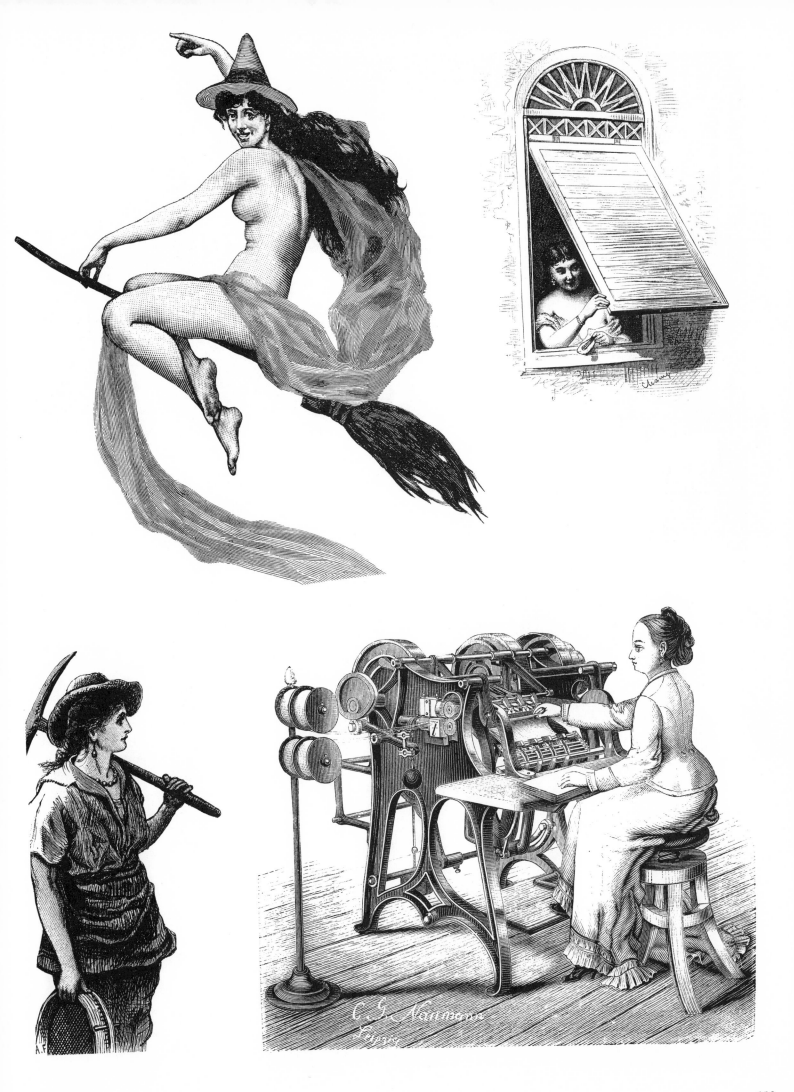

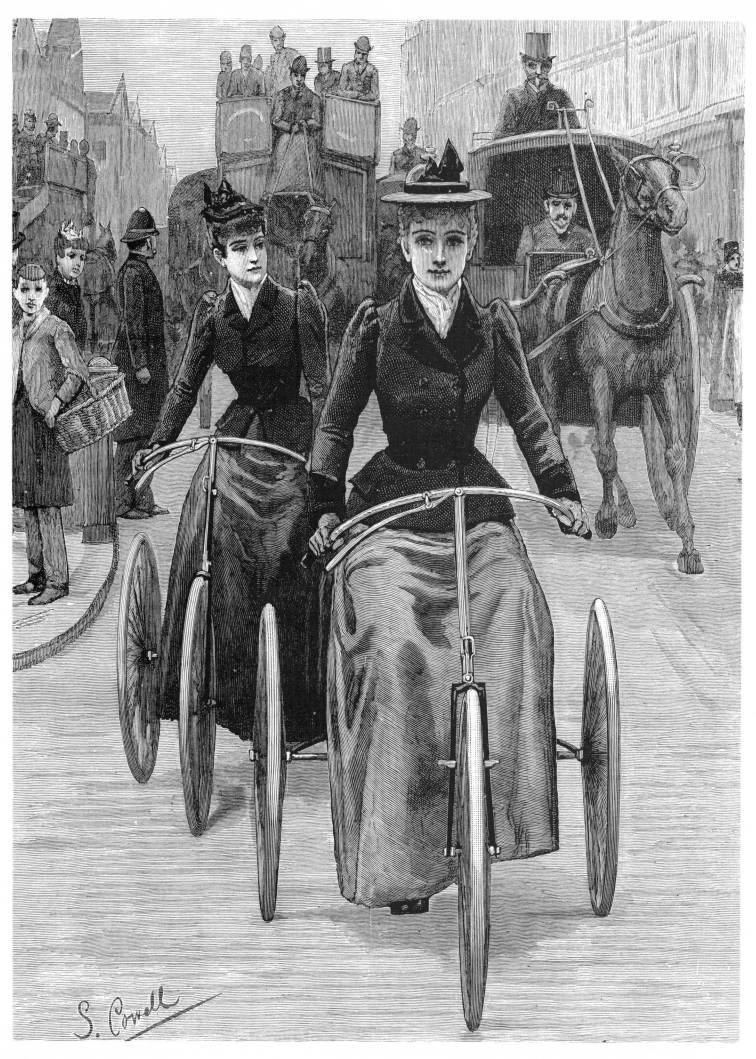